NEW JERSEY ARTISTS
THROUGH TIME

TOVA NAVARRA

AMERICA
THROUGH TIME®
ADDING COLOR TO AMERICAN HISTORY

To Roman Alexander Navarra with love

ON THE COVER:
Upper image: George Segal with the tableau "Gay Liberation" in his studio, 1980. Photograph by Tova Navarra. *Lower image:* Young couple view paintings by Clarence Carter at an exhibit in Easton, PA. Photograph by Tova Navarra.

AMERICA THROUGH TIME is an imprint of Fonthill Media LLC

Fonthill Media LLC
www.fonthillmedia.com
office@fonthillmedia.com

First published 2015

ISBN 978-1-63500-011-5

Typeset in Mrs Eaves XL Serif Narrow
Printed and bound by CPI Group (UK) Ltd, Croydon, CR0 4YY

Connect with us:
www.twitter.com/usathroughtime
www.facebook.com/AmericaThroughTime

AMERICA THROUGH TIME® is a registered trademark of Fonthill Media LLC

Introduction

"We need (the arts)...like medicine. They help us live."
President Barack Obama

In 1964, William H. Gerdts, Jr. wrote in *Painting and Sculpture in New Jersey*, of *The New Jersey Historical Series* (D. Van Nostrand Company, Inc.): "This book is the first ever to deal with... painting and sculpture in New Jersey. Space limitations...made it necessary to eliminate... graphic arts and...illustrative art and cartoons, in the development of which New Jersey artists have played a significant part. Perhaps, someday, their history will be recorded."

That "someday" is here, and, exponentially, deals with many of the finest past and current artists with significant ties to New Jersey – their painting, sculpture, photography, printmaking, mixed media, illustration, and cartoons. Although many artistic efforts have their detractors, I hope readers relate to my stepping "unto the breach" – that "hole" in our history, as it were – and seizing the opportunity to cobble some missing pieces. To do what my photographer-idol Dorothea Lange would have asked me to do: "grab a hunk of lightning."

Despite space limitations, this book celebrates New Jersey's 350th anniversary as the first book ever to juxtapose past and present artists from John Watson in the 1700s to artists in 2014. Most daunting was acquiring images; without resources for expenses, I regret that museums, artists' rights agencies, and other entities charge prohibitive fees for photos and reproduction permission. However heartbroken I felt to forgo images of numerous treasured artists, I do offer a list of them, thus sparking my desire to do a second volume. New Jersey has a staggeringly rich art history growing with unprecedented intensity.

Because literature on past artists is readily accessible, my main goal was to give current artists not critiques or reviews, but well-deserved limelight to augment their exposure in our art museums (more than forty-five, the Newark Museum being the largest), galleries, corporate collections, colleges and universities, and myriad public buildings.

New Jersey artists' settlements blossomed and deserve recognition as well. For example, the 1890s brought forth the Ridgefield Artist Colony at the top of the Palisades, a comforting retreat from New York City and Philadelphia. The Garden State proved

inspiration, particularly for landscape painting, and attracted luminaries such as French-American artist Marcel Duchamp, and even drew in the likes of New Jersey poet William Carlos Williams and a good number of art benefactors. (Walter Conrad and Louise Arensburg, Duchamp's patrons, requested his painting "The Large Glass" in lieu of rent. Duchamp declined.) Other hubs emerged in Elizabeth, Newark, Bordentown, Jersey City, Hoboken, and Perth Amboy. In Nutley, artist Frank Fowler (1852-1910) bought home #16 in The Enclosure community to which he added a huge studio. It was to become home to artists including Frederick Dana Marsh, Reginald Marsh, and from 1942 to 1972, it was home to Michael Lenson, leading WPA muralist. The 1914 opening of the Montclair Art Museum – the only museum in the world with a gallery devoted solely to George Inness – beckoned artists to Montclair.

That artists tend to gather speaks to the oft-unsung bond between past and living artists: they are our philosophers, documentarians, teachers, and collective confidants whose work must not be forgotten or neglected. Journalist Yolanda Fleming said, "A piece of art is a tangible home where emotions and ideas can exist apart from their creator." In sum, many mansions with many rooms to live in, learn from, and cherish through the ages.

Art students enjoy studying with prominent artists who teach at colleges and universities. To name a few of the past, Roy Lichtenstein taught at Douglass College (Rutgers University) starting in 1964, and George Segal and Leon Golub taught at Rutgers' Mason Gross School of the Arts. Leo Dee headed the Newark School of Fine and Industrial Arts during its "Golden Age," its population including our state's Ashcan school artists such as John Grabach and Henry Gasser. The revered artist and teacher Robert Henri, who lived in Atlantic City, was an important leader of the Ashcan movement. From the Newark School came some of our finest artists and educators. On a personal note, doing this book was a heady "art course," reinforcing for me that "art is a really cool way of making something matter to somebody," as Jason Poole, a New Jersey paleontology artist, said in a "State of the Arts" NJ public television show on "Haddy," Hadrosaurus foulkii, the world's first complete dinosaur skeleton ever found. The site was Haddonfield, Camden County, on which is a park and a dinosaur sculpture by John Gianotti.

"The arts industry...sustains public value," says the mission statement of the New Jersey State Council on the Arts (NJSCA), established in 1966, "both intrinsically to the lives of people and instrumentally to the advancement of communities." The NJSCA champions the arts for giving "identity and character to towns and neighborhoods," boosting tourism, and attracting corporations to grow in our "astonishing cultural diversity."

In New Jersey, Gerdts wrote, "one can trace the...development of American art on a more local scale. Some of these artists were, indeed, the leading painters in the country... although many were...independent creative spirits reacting to the Zeitgeist."

As you turn these pages, then, I invite you to revel in New Jersey's select, artistic Zeitgeist. I hope it leaves you wanting more, especially for our future artists.

Tova Navarra
Middletown, NJ, August 2015

JOHN WATSON (1685-1768):

An unknown artist sketched this portrait of the Scottish-born American artist, first a house painter, then portraitist. Watson's immigration led him to Perth Amboy in 1715, where he bought a house on the bluffs. He lived among his paintings, and the house became known, according to early historian William Dunlap, as the first art collection in America. Watson's nephew, heir to the estate, fled Perth Amboy, leaving colonial forces to raid the collection in 1776. The works – portraits of kings, English heroes, and New Jersey political luminaries – were most likely destroyed or stolen save for a few, including portraits of New Jersey Governors Lewis Morris (collection of the Brooklyn Museum) and William Burnet (now in the Massachusetts State House in Boston), and William Eier, first mayor of Perth Amboy. Watson is buried in St. Peter's Episcopal Cemetery, Perth Amboy. Image of John Watson from Wikipedia.

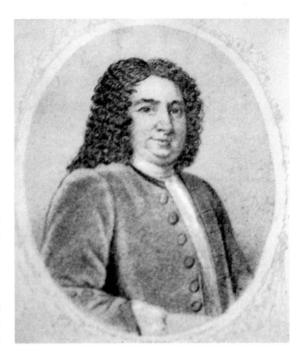

PATIENCE LOVELL WRIGHT

(1725-1786): Wax sculptures made by Wright, born in Oyster Bay, NY, and moved to Bordentown at age four, brought her recognition as the first American-born sculptor. Her Quaker family had a farm at 100 Farnsworth Avenue, but she took up a popular colonial art form of molding portraits in tinted wax. After Wright's husband, an older barrel-maker, died in 1769, she and her sister enjoyed success with wax sculptures until a 1771 fire destroyed them all. Wright moved to England and found favor through Benjamin Franklin, and sculpted King George III and other royals. But she was accused of spying for the colonial cause during the American Revolution and sought refuge in Paris, where she was unsuccessful. She returned to New Jersey, and within several days she died from complications of a broken leg. With small support of the Continental Congress, she was buried in an obscure London grave. Wright's only surviving wax sculpture (of William Pitt) is in Westminster Abbey. One of her children, Joseph Wright, became an artist. Drawing of Patience Wright dancing, image from the London Magazine, 1775.

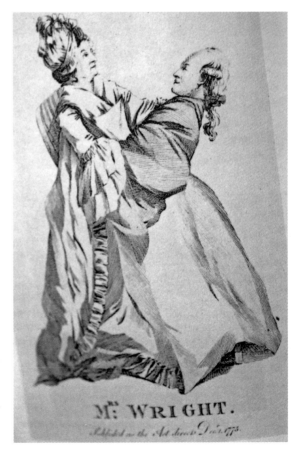

MRS WRIGHT.

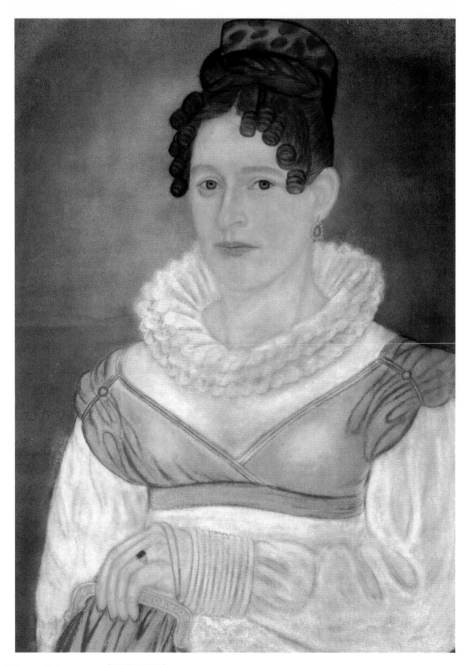

MICAH WILLIAMS (1782-1837): It is unclear whether Williams was born in Essex or Middlesex
County, but today he might be called a "traveling salesman" of artists. An itinerant portraitist,
Williams set about doing portraits along the Great Eastern Butter Belt – mostly Freehold, Marlboro,
Middletown – so named because farmers in these towns raised dairy cows and crops for New
York and Philadelphia markets. Williams was arrested and jailed in 1814 for some infraction.
There is a dearth of information about his life in general. This portrait is formally credited as
"Micah Williams (1782-1837), Sarah Van Mater Disbrow (1793-1875), possibly New Brunswick
area, Middlesex County, New Jersey, after 1820; pastel on paper, 30 ¾ x 26 ½ inches, Monmouth
County Historical Association: Bequest of Henry W. Disbrow, 1936."

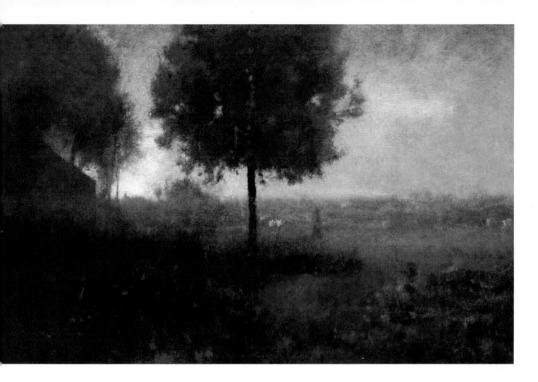

GEORGE INNESS (1825-1894): As a landscape painter of Montclair, Inness's work derives much from the Romanticism and natural Impressionism popular in his lifetime. Born in Newburgh, NY, Inness moved at age five to Newark, NJ, then to Massachusetts, to Eagleswood, NJ, and settled finally in Montclair in 1885. The father of six children by his second wife, he was influenced by the Barbizon and Hudson River schools and the "Land Storm" principles and landscape styles of Gaspard Poussin and Claude Lorrain. With the additional influence of theologian Emanuel Swedenborg, Inness embraced the mystical side of nature. *Above*: "Misty Morning, Montclair" (alternate title "Hazy Morning, Montclair"), courtesy of The Butler Institute of American Art. *Right*: Photograph of Peto in Philadelphia which belongs to the John F. Peto Studio Museum. Courtesy of The Butler Institute of American Art.

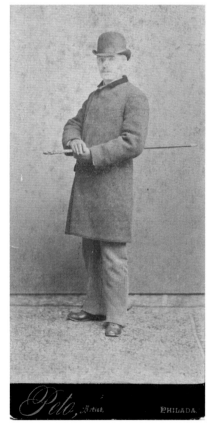

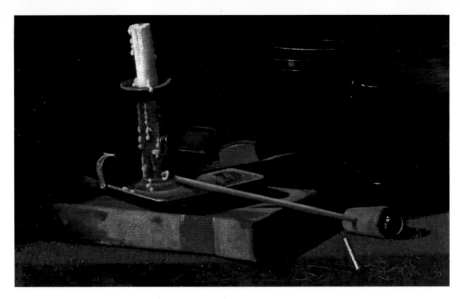

JOHN FREDERICK PETO (1854-2004): A Philadelphia native, Peto studied at the Pennsylvania Academy of the Fine Arts and began his career in association with painter William Harnett by doing inexpensive "rack paintings" for unsophisticated businessmen. Harnett and Peto painted trompe-l'oeil ("fool-the-eye") still-lifes, which were often jeered as novelty. Two years after marrying Christine Pearl Smith of Ohio, Peto designed and built a house at 102 Cedar Avenue in Island Heights, a New Jersey resort town. There he painted in obscurity, never having a gallery exhibition, until his death. Today Peto is considered an American master of trompe-l'oeil, and his home is now the John Frederick Peto Studio Museum, opened in 2011 and on the National Register of Historic Places. Peto's work is in museums throughout the states – the Metropolitan Museum of Art, Art Institute of Chicago, Princeton University Art Museum, Newark Museum, among many others. *Above*: Oil painting "Book, Mug, Candlestick and Pipe" by Peto, which belongs to the John F. Peto Studio Museum. Courtesy of The Butler Institute of American Art. *Below:* "Cakes and Ginger Jar" oil painting by Peto, at the John F. Peto Studio Museum. Courtesy of The Butler Institute of American Art.

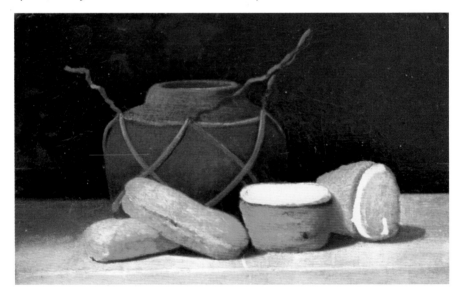

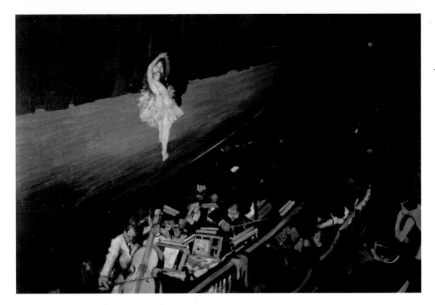

JOHN GRABACH (1886-1981): One of the Ashcan school artists, Grabach was born in Greenfield, MA, and came to Newark at age eleven. When he was eighteen, he worked in a silverware company designing silverware items, Art Deco glass, US postage stamps, and greeting cards. At night he took classes at the Art Students League and began to paint. In 1935 he started teaching at the Newark School of Fine and Industrial Arts. He taught more than 8,000 students, and his art was exhibited in major museums including the Philadelphia Art Alliance and the Art Institute of Chicago from the 1920s to the 1960s. His paintings of the blue-collar streets and subjects of New York and Newark won acclaim as American masterpieces. In addition, Grabach wrote his book, *How to Draw the Human Figure*. His student Henry Gasser wrote *The Career of John R. Grabach, American Artist* in 1964. Grabach's work was given a solo exhibition at the Smithsonian in 1980, one year before his death. *Above:* Grabach's "The Ballet,"courtesy of Gary T. Erbe. *Below:* "Men Painting Houses," by Grabach, courtesy of Gary T. Erbe.

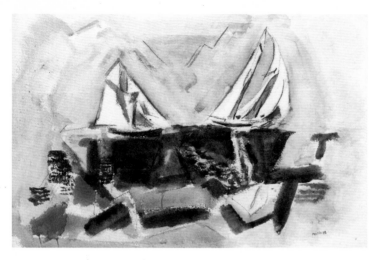

JOHN MARIN (1870-1953): Nine days after Marin was born in Rutherford, his mother died and he was raised by two aunts in Weehawken. He studied at Stevens Institute of Technology, Hoboken, and the Art Students League, NYC. He was first presented to the American art world by distinguished photographer and Hoboken native Alfred Stieglitz. Marin's work reflected Fauvist, Cubist, and European modernist styles, which he brought into American themes. Initially trained as an architect, Marin also studied in Paris and spent a significant amount of time painting in Maine. His first solo exhibition was held at Stieglitz's 291 Gallery in New York. He also exhibited in the landmark Armory Show of 1913. Among his accolades was his 1936 retrospective at the Museum of Modern Art (MoMA). Marin, who also lived for a time in Cliffside Park NJ, died in Maine. He is buried in the Fairview, NJ, Cemetery. John Marin's watercolor "Schooner Yachts, Deer Isle, Maine," courtesy of The Butler Institute of American Art.

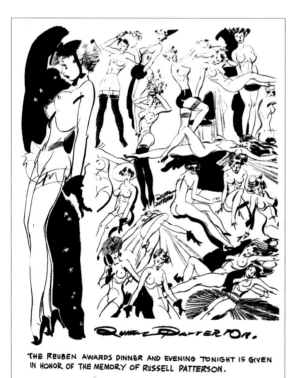

THE REUBEN AWARDS DINNER AND EVENING TONIGHT IS GIVEN IN HONOR OF THE MEMORY OF RUSSELL PATTERSON.

RUSSELL PATTERSON (1893-1997): Born in Nebraska, Patterson studied at McGill University and started contributing to Montreal magazines. He studied in Paris and returned to do advertising art in Chicago. He also studied at the Art Institute of Chicago, and thereafter traveled to the southwest with his paintings, which galleries rejected. In 1925 in Manhattan, he redirected his art to doing covers and interiors for magazines including *Life* and *Ballyhoo*. Then came his flappers, based on his sketches of women in Paris, and modern Jazz Age women graced the covers and in the pages of *The Saturday Evening Post*, *Vogue*, *Cosmopolitan*, *Vanity Fair*, and other publications. The famous "Gibson Girl" gave over to the "Patterson Girl." Later Patterson worked as costume and scenic designer for Broadway productions including *The Ziegfeld Follies of 1934* and films. In the 1940s he produced comic strips for Hearst's King Features Syndicate called "Pin-up Girls." *Continues on page 13.*

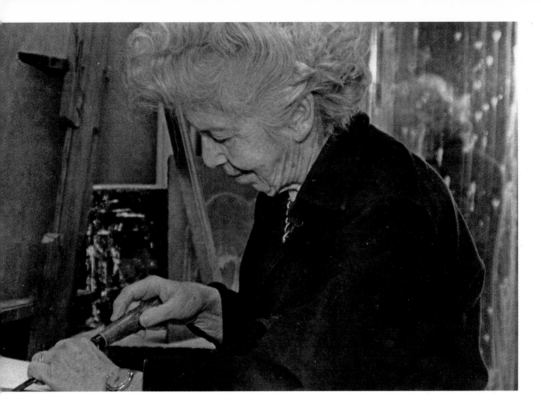

DOROTHEA GREENBAUM

(1893-1986): A native New Yorker, Greenbaum worked in New York until moving to Princeton, where she lived the rest of her life. She is best-known today for her sculptures. She suffered the loss of her father, who died on the *Lusitania*, but her inheritance supported her so she could do her artwork without financial hardship. Greenbaum produced work in clay, stone, and metal; her most famous works are of hammered lead. Her sculptures are known for their serene and humanitarian quality. The Newark Museum owns a number of them. Typical of her work are sculptures including "Girl with a Scarf" and "Blowing Leaves," cast in bronze. *Above:* Photograph of Dorothea Greenbaum in her studio, courtesy of Judith K. Brodsky. *Right:* A Greenbaum print "Woman," courtesy of Judith K. Brodsky.

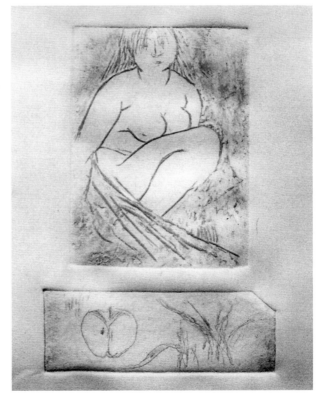

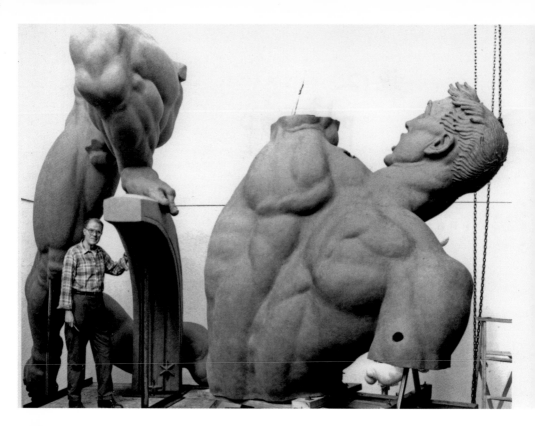

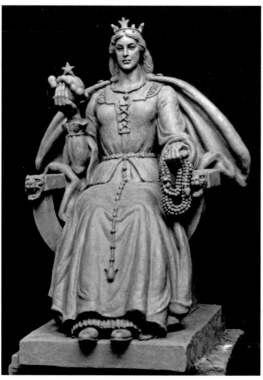

DONALD DE LUE (1897-1988):

De Lue was born in Boston and studied at the Boston Museum of Fine Arts, followed by five years in Paris, where he worked as an assistant to various French artists. He returned to the United States and in 1940 was elected into the National Academy of Design and became a full Academician in 1943. Best known for his public monuments, De Lue's work is in many museums across America. He also designed medals and medallions. He taught at the Beaux-Arts Institute of Design, NY, and he was given awards by the National Sculpture Society for outstanding collaboration of sculptor and architect. His wife, Naomi, served as model for many of his statues. The two lived in the Leonardo section of Middletown Township. He maintained his NYC apartment, but he created his largest statues in the Leonardo studio. *Above:* Photograph of De Lue with clay model of "Rocket Thrower," weighing more than ten tons. From the collection of Tova Navarra. *Left:* De Lue's statue of Queen Isabella of Spain in bronze, from the collection of Tova Navarra.

Continued from page 10:
In 1951 Patterson created the cartoon "Mamie," a flapper strip that ran until 1956. In the 1960s he taught at the National Institute of Art and Design, judged Miss America and Miss Universe pageants, and received prestigious awards. Patterson died in Atlantic City just as the Delaware Art Museum was preparing his first retrospective. In 2006, Fantagraphics published *Top Hats and Flappers: The Art of Russell Patterson*. Image from a tribute booklet to Patterson, from the collection of Tova Navarra.

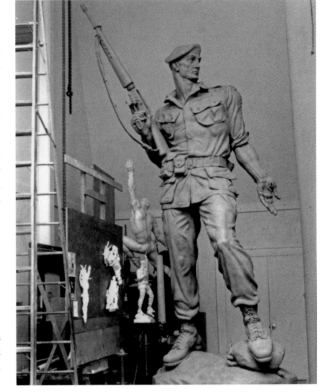

De Lue's clay model of the "Green Beret" statue, sixteen-feet high, cast in bronze, displayed at Fort Bragg, NC, from the collection of Tova Navarra.

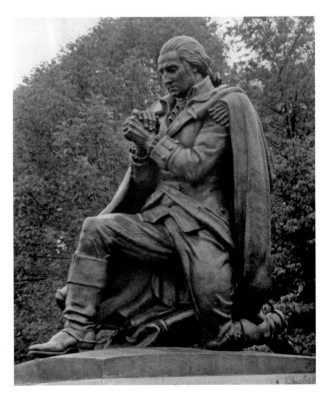

Bronze ten-foot kneeling statue of General George Washington by De Lue, Valley Forge, PA, from the collection of Tova Navarra

BEN SHAHN (1898-1969): Shahn was born in Lithuania, then occupied by the Russian Empire. His family immigrated to the US, to Brooklyn, NY, in 1906. Shahn was first trained as a lithographer and graphic artist. Developing a style known as Social Realism, he traveled through North Africa and then Europe, where he studied with artists including Matisse, Dufy, Rouault, Picasso, and Klee. He is famous for his twenty-three gouache paintings of the trials of Sacco and Vanzetti, exhibited in 1932. He worked during the Great Depression, and his series of California labor leader Tom Mooney won him the attention of Mexican artist Diego Rivera. Shahn assisted Rivera in the painting of The Rockefeller Center mural. Around this time, Shahn married photo-journalist, painter, illustrator, and lithographer Bernarda Bryson. With photographers Walker Evans and Dorothea Lange, Shahn documented the American South. He also worked for the Resettlement Agency, and painted a fresco mural for the Community Center of Jersey Homesteads, now Roosevelt, NJ. Shahn's diverse works are in the permanent collections of many American museums, including the New Jersey State Museum and Newark Museum. Shahn's writings include *The Biography of Painting*, 1956, and *The Shape of Content*, 1960. *Left:* Photograph of Shahn courtesy of Saliba Sarsar. *Below:* "TV Antenna," also called "Caliban," from the collection of John and Ellen Lander Brodsky, used with permission of the collectors, courtesy of Judith K. Brodsky.

CLARENCE HOLBROOK CARTER (1904-2000): Born in Portsmouth, Ohio, Carter did his first drawing in 1910 called "Tracy, Chris, and Skeet," which he considered his flagship drawing. His initial figurative style evolved into his late surrealistic paintings and drawings. From 1923 to 1927, Carter studied at and was graduated from the Cleveland School of Art, and thereafter studied with Hans Hofmann in Capri, Italy. In the 1940s, he depicted people during the Great Depression, and years later moved on to more allegorical work. The husband of Mary Griswold Carter and father of two sons, Carter became a full National Academician in 1964. Toward the end of his life, Carter turned to thanatological themes using a signature ovoid as a symbol of the human body and soul. *Continues on page 16.*

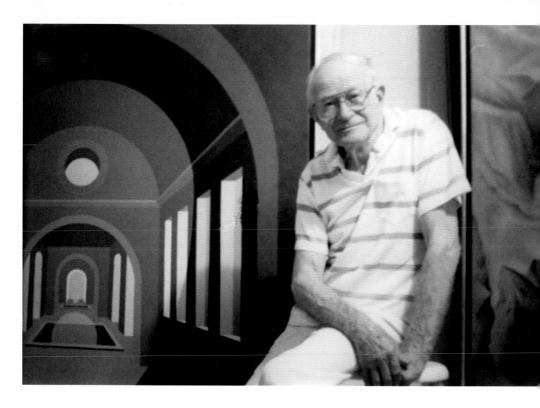

Carter's work is in many museum collections, among them the Smithsonian American Art Museum, Carnegie Museum of Art, and the Whitney Museum of American Art. In 1989 Rizzoli published a monograph on Carter's paintings, *Clarence Holbrook Carter*. A monograph titled *Assertions on Paper, 1910 to 1990: The Drawings of Clarence Holbrook Carter*, with a foreword by James A. Michener and introduction by George Segal, is in progress. *Above:* Carter in front of a later painting, photograph by Tova Navarra. *Left:* Girls sit under one of Carter's "Over and Above" paintings at an exhibition in Easton, PA. Photograph by Tova Navarra.

Continued from page 15:
Upper image: Photograph of Bernarda Bryson Shahn (1903-2004), left, and Elizabeth ("Liz") Dauber, wife of artist Gregorio Prestopino, courtesy of Saliba Sarsar. *Lower image:* Charcoal drawing "Little Women," photograph by the Cleveland Museum of Art, courtesy of Clarence Carter, from the collection of Tova Navarra.

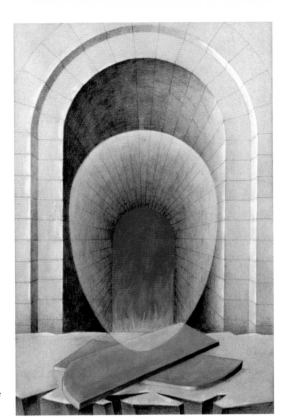

Carter's "Descent into Limbo," pencil-and-acrylic on gray paper, from the collection of Tova Navarra.

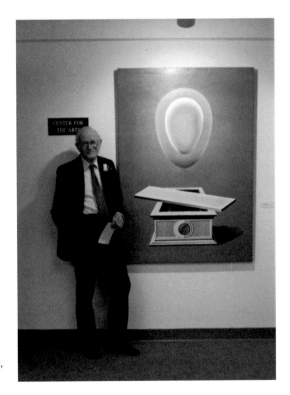

Carter poses next to a "Thanatopsis" painting, photograph by Tova Navarra.

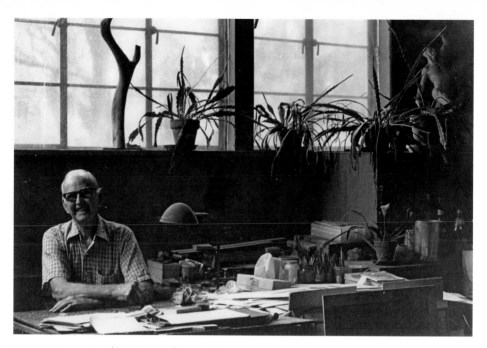

AVERY JOHNSON (1906-1990): A 1928 graduate of Wheaton College and, in 1933, the Art Institute of Chicago, Johnson was a native of Wheaton, Illinois. From 1947 to 1960, he taught at the Newark School of Fine and Industrial Arts. He also taught art at the Montclair Art Museum from 1940 to 1970. Johnson, who had a wife, Nina Johnson, and daughter, painted murals including "Skating on Bonaparte's Pond," 1940, in the Bordentown, NJ, post office. Other murals are in Marseilles, Illinois; Liberty, Indiana, and North Bergen, NJ. Johnson was active in Denville and Dover, NJ. He died in Hackettstown. *Above:* Photograph of Avery Johnson by Tova Navarra. *Below:* Photograph of Prestopino by photographer Sol Libsohn, courtesy of Paul and Sara Prestopino.

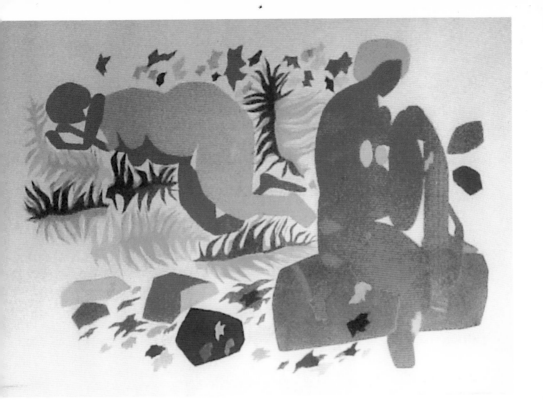

GREGORIO PRESTOPINO (1907-1984):

Best known for his Social Realism and New York Figurative Expressionism, Prestopino, born in "Little Italy," NYC, was to move to the Roosevelt, NJ, artists' community in 1949. At age fourteen, he was given a scholarship to the National Academy of Design, and as his work progressed, he painted in the Ashcan style, which concentrated on urban and working-class themes. He created a series for Life magazine in 1957 based on an article about a New York state prison, and later in the 1950s he focused on Harlem subjects. The film *Harlem Wednesday* won top honors at the First International Festival of Art Film in Venice. Prestopino's Harlem paintings appeared in every scene. In 1954 Prestopino was director of the MacDowell Colony in New Hampshire, where his friends included Milton Avery and other MacDowell Fellows. Later his work turned toward abstract, Cubist, mythological, and nature themes. His paintings are in the permanent collections of MoMA; Whitney Museum of American Art; Art Institute of Chicago; Smithsonian American Art Museum; New Jersey State Museum; and others. *Above:* "Two Nudes," a silkscreen by Prestopino, courtesy of Judith K. Brodsky. *Right:* Photograph of Henry Gasser by Tova Navarra.

HENRY MARTIN GASSER (1909-1981): A lifelong New Jerseyan, Gasser was born in Newark and studied at the Newark School of Industrial and Fine Arts, the Grand Central Art School in New York, and the Art Students League. At the League he became a devoted student of John Grabach, and Gasser's work reflected his mentor's Ashcan style. The two traveled to Massachusetts to paint, but Gasser's roots in Newark provided him with images of the industrial growth that went into his urban Depression subjects. In 1930 Gasser married and became known for his watercolors. After being stationed in North Carolina during World War II, he taught at the Newark School; from 1946 to 1954 he was director. His work received awards from the Baltimore, Philadelphia, and Washington Water Color clubs, the Mint Museum of Art, and the Montclair Art Museum, and membership in more than twenty prestigious art organizations including the National Academy of Design. He also published the books *Techniques of Painting the Waterfront*, *Techniques of Picture Making*, and *Oil Paintings: Methods and Demonstrations*. He died in South Orange, NJ. *Above:* "Winter Corner," painting by Gasser, courtesy of Gary T. Erbe. *Below:* Gasser's watercolor "From Bay Hill," courtesy of Gary T. Erbe.

JANE SIMON TELLER (1911-1990): Teller apprenticed in her father's woodworking factory in upstate New York and went on to study at Rochester Institute of Technology and Columbia University. In New York she met photographer Aaron Siskind, who became her friend and mentor, in an art class sponsored by the Works Progress Administration (WPA). He introduced her to abstract expressionist artists Jackson Pollock, Willem de Kooning, and Franz Kline. A sculptor working in wood, iron, and Plexiglas, Teller concentrated on the life quality in objects she called "thingness." She used recurring symbols – circles, arcs, cubes. *Continues on page 22.*

SOL LIBSOHN (1914-2001): Born in Harlem, NY, to immigrant parents from Poland and Russia, Libsohn's earliest influences on art drew him into photography. He was self-taught, but he took night courses at the City College of New York. Along with fellow photographer Sid Grossman, Libsohn established The Photo League in 1936 after The Film and Photo League disbanded. Libsohn moved to Roosevelt, NJ, in 1946. Soon after, he did photographic work for Standard Oil of New Jersey Project (SONJ) headed by Roy Stryker, and also worked for Stryker's other projects. In the 1950s Libsohn did free-lance photographs for *Fortune* and *Ladies' Home Journal* magazines. *Continues on page 22.*

Continued from upper caption, page 21:
At first, she made her sculptures playfully and spontaneously, thereafter making numerous adjustments "calculated to trap the quality that will be the expression of the sculptor [...]." She and her husband, writer Walter Teller, bought a large farm near Plumsteadville, NJ, in 1938. Later they moved their family to Princeton. In 1984 Teller suffered a stroke but worked until she died. A collection of her memoirs and essays was posthumously published by her husband. Print by Teller, "Woman," courtesy of Judith K. Brodsky.

Continued from lower caption, page 21:
His work was included in the much-lauded "Family of Man" exhibit at MoMA, 1955. The father of two children, Libsohn taught at Trenton High School and Princeton University and remained active in the arts until his death. Photograph by Sol Libsohn, courtesy of Paul and Sara Prestopino.

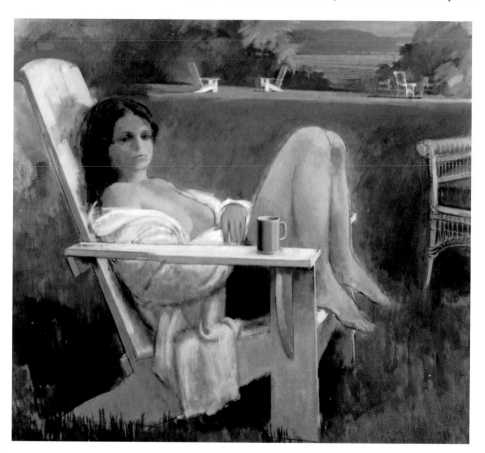

ADOLF KONRAD (1915-2003): Growing up in Bremen, Germany, Konrad absorbed the area's great commerce and culture and thus acquired his love of art. He moved to the United States and studied at the Newark School of Fine and Industrial Arts and the Cummington School, MA. An American realist, Konrad is considered one of the leading New Jersey painters to this day. He taught at Newark State College, now Kean University. Konrad and his wife, Adair, also a painter, lived in rural Asbury, NJ (not to be confused with Asbury Park) in Warren County. One of Konrad's best-known paintings, "Reflections," 1960, is in the permanent collection of the Newark Museum. Konrad's paintings are owned by many corporations and museums including the New Jersey State Museum; National Academy of Design; AT&T in Bedminster; and the Forbes Collection, NY. Adolph Konrad's "Figure in the Garden," 1978, from the collection of Tova Navarra.

JACOB LANDAU (1917-2001): One of the Roosevelt, NJ, artists, Landau was born in Philadelphia. As a twelve-year-old he studied at the Graphics Sketch Club (the Samuel Fleisher Memorial). At seventeen, he illustrated Kipling's "Jungle Book" and won his first competition in *Scholastic Magazine*. He studied at the Museum School of Industrial Art, now known as The University of the Arts. In 1939 he worked as a professional artist and illustrator in New York. After a two-year stint in the Armed Forces, Landau studied and spent 1948-49 at the New School for Social Research, NY, before he and his wife, Frances, moved to Paris, where he met artist Leonard Baskin. Landau taught at the Philadelphia College of Art, Pratt Institute, and the Art Teacher Institute, a residency program sponsored by the New Jersey Council on the Arts. He was active in community organizations such as the New Jersey School for the Arts and was elected into the National Academy of Design in 1974. The Landaus had two sons, Jonas and Stefan.

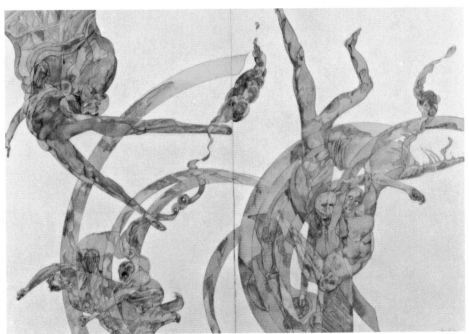

In 1993 Frances died. Landau died at age eighty-five and is buried in the Roosevelt Cemetery near his friends Ben Shahn and Gregorio Prestopino. Landau's work has been exhibited in the Whitney Museum of American Art; New Jersey State Museum; Philadelphia Art Alliance; and Hirschhorn Museum in Washington, DC. The Jacob Landau Institute works for artistic endeavors in conjunction with Monmouth University, West Long Branch. *Upper image:* Photograph of Jacob Landau by Rosa Giletti (board member of the Jacob Landau Institute), courtesy of the Monmouth University Department of Art and Design. *Lower image:* "Satanic Wheels" by Landau, courtesy of the Monmouth University Department of Art and Design.

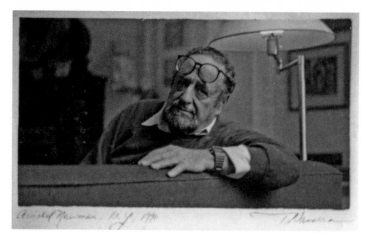

ARNOLD ABNER NEWMAN (1918-2006): An environmental portraitist, Manhattan-born Newman grew up in Atlantic City. In 1936 he studied painting and drawing at the University of Miami, thereafter moving to Philadelphia and making portraits in 1938 for forty-nine cents. He relocated to New York in 1946 and opened the Arnold Newman Studios. His photographs were then seen in *Fortune*, *Life*, and *Newsweek* magazines. His major success as a photographer is attributed to the humanistic quality in his portraits; Pablo Picasso, Marilyn Monroe, Audrey Hepburn, John F. Kennedy, Piet Mondrian, and – perhaps his best-known image taken in 1946 – a black-and-white portrait of Igor Stravinsky seated at a grand piano, are among the multitude of subjects. Photograph of Arnold Newman by Tova Navarra. *Continues on page 25.*

MARGARET KENNARD JOHNSON (1918-): A traveler on all seven continents and Princeton resident since 1948, Johnson is a printmaker who also creates handmade paper, collages, and creative playthings (sold in the Museum of Modern Art Store). She studied with Josef Albers and Jose de Creeft at Black Mountain College, NC, after earning a BA from Pratt Institute and an MA from University of Michigan's School of Architecture and Design. Born in Madison, WI, Johnson married Edward O. Johnson in 1947 and raised two daughters, artist Lonni Sue (see page 80), and Aline. In addition to count-less exhibitions (many in Japan where Johnson lived for eight-and-a-half years), she created prints for the Brodsky Center for Innovation Editions, Rutgers University, and is a founding member of both the Princeton Artists Alliance and Movis (eight artists) in NJ. Photograph of Margaret Johnson, courtesy of Judith K. Brodsky. *Continues on page 28.*

Continued from page 24:
Newman was one of the very few photographers who photographed Henri Cartier-Bresson, a famous but camera-shy photographer. Newman also made an eerie portrait of convicted former Nazi slave-labor boss Alfried Krupp. Newman taught photography at Cooper Union for many years. His book *One Mind's Eye, the Portraits and other Photographs of Arnold Newman*, was published by David R. Godine in 1974. Among Newman's many awards is the 2004 Royal Photographic Society's Centenary Metal and Honorary Fellowship.

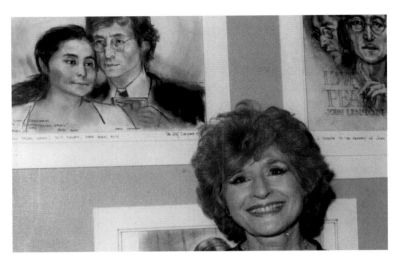

IDA LIBBY DENGROVE (1919-2005): Born to an impoverished Philadelphia family, Dengrove (*née* Leibovitz) and her twin sister, Freda, spent summers in Atlantic City sketching portraits for $1, and caught the attention of wealthy arts patrons. She studied at Moore College of Art and Design, Philadelphia, was mentored by Albert Barnes, studied at the Barnes Foundation, Merion, PA, and won a scholarship to study in France 1939, but chose instead to study with Diego Rivera in Mexico. *Above:* Photographs of Dengrove with sketches of John Lennon and Yoko Ono, courtesy of Lois Ann Dengrove. *Below:* Dengrove's sketch from the "Son of Sam" trial, courtesy of Lois Ann Dengrove.

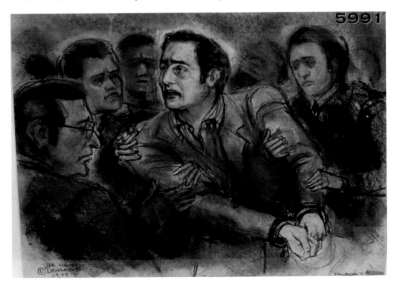

25

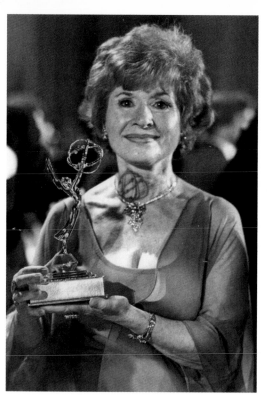

Again in the US, Dengrove worked for the USO touring hospitals and doing portraits of wounded soldiers for their loved ones. While on tour, she married Dr. Edward Dengrove, a flight surgeon with the Flying Tigers in China. After the war, the couple moved to Asbury Park and raised three children. In 1972 following in her sister's footsteps as court sketch artist for ABC News, Dengrove was hired by WNBC in New York. Not only would she sketch many of the most famous trials in American history – "Son of Sam" and "Murder at the Met," each earning her an Emmy – but she is credited with overturning the courts' policy against photographers and sketch artists who were considered disruptive and degrading to the judicial process. With NBC, she won the NJ Supreme Court's 1974 decision that opened the courts for all artists. She left more than 6,000 drawings that spanned nearly three decades of court activity. Her family donated the majority of her works to the University of Virginia Law Library. *Left:* Dengrove holding an Emmy, courtesy of Lois Ann Dengrove. *Below:* Dengrove's sketch of John Africa's "MOVE" trial, 1981, courtesy of Lois Ann Dengrove.

436

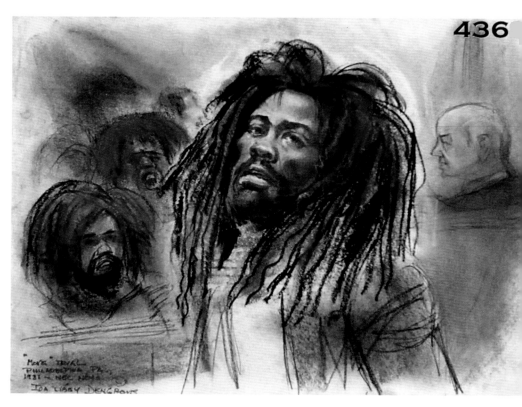

DAVID KWO (1919-2003): A master of Chinese painting born in Beijing, Kwo Da-Wei studied at the Art Institute of Nanjing and with the master Qi Bai-Shih. In 1957 Kwo's fame arose with his brush paintings of a provocative black cat, Kim, his paintings of lotuses, which Kwo called "The Gentlemen of Flowers," his landscapes (notably "yellow mountains"), and portraits of animals and people in plays and Chinese operas. Also a master of Chinese calligraphy, Kwo was an art professor at colleges including Seton Hall University. In 1981, he published *Chinese Brushwork* and wrote extensively for periodicals and newspapers worldwide, including fifty-two articles called "Letters to Art Lovers" in the mid-1900s for the *Jakarta Post*, Singapore. In 2000 a retrospective of his life's work was exhibited in Singapore. He had twenty-three solo exhibitions in art museums and forty-one in art galleries and institutions all over the world. Faux-diptych watercolor portrait of David Kwo by Tova Navarra, 1975. Faux-diptych watercolor portrait of David Kwo by Tova Navarra, 1975.

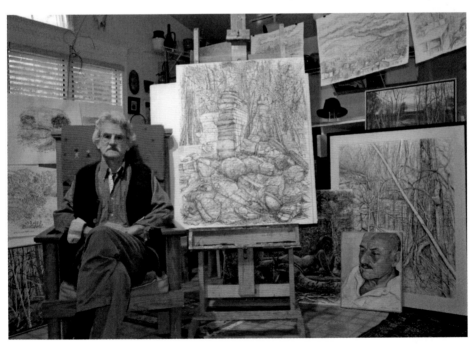

JON NAAR (1920-): Since 2000 Naar has lived in Trenton and is a London-born author and photographer, lauded for his pioneering images of NYC graffiti in the 1970s. He published nine books including *The Faith of Graffiti*, the first book on the subject with an introduction by novelist Norman Mailer. In 2013 the New Jersey State Museum mounted an exhibition of his work entitled "Jon Naar: Signature Photography." His photograph "Shadows of Children on Swings" is in the permanent collection of the Metropolitan Museum of Art. He photographed Andy Warhol, Henry Moore, Barnett Newman, Marcel Breuer, Josef Albers, and others. Jon's cousin, Harry I. Naar, born in New Brunswick in 1946, is a professor of fine arts at Rider University, Lawrenceville, NJ. *Continues on page 28.*

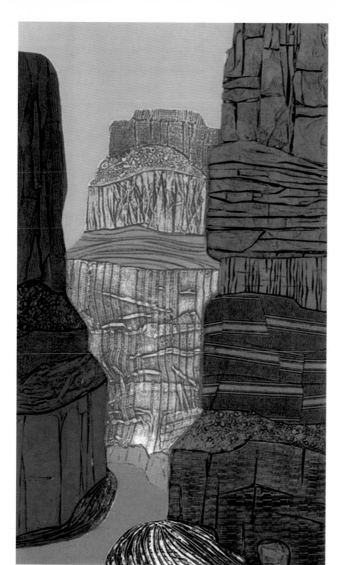

Continued from page 24:
Johnson also taught at the School of Visual Arts, Princeton. The author of *Japanese Prints Today: Tradition with Innovation*, published in Tokyo, 1980, Johnson has works in the permanent collections of museums including The British Museum, London; Library of Congress; Cleveland Art Museum; New Jersey State Museum; Tochigi Perfectural Museum, Utsunomiya, Japan; and Firestone Library Graphic Arts College at Princeton University.

Continued from page 27:
His paintings and drawings are in the permanent collections of Morris Museum of Arts and Sciences; New Jersey State Museum; Jane Voorhees Zimmerli Museum; Hunterdon Museum of Art; Jersey City Museum; New York Museum; Montclair Art Museum; and others. Photograph of Harry I. Naar in his studio by Jon Naar, Copyright 2015.

JOHN ROSS (1921-): While growing up in the Bronx, Ross went with his instinct to study art from high-school classes to the New York School of Fine and Applied Arts (now Parsons), focusing on graphic arts, etching, painting, illustration, and typography. He also studied at Cooper Union with Morris Kantor, Will Barnett, and other influential teachers. With a background also in architecture and advertising, Ross married fellow Cooper Union art student Clare Romano (see pages 29-30) before he was shipped to Italy in 1943 as a member of the US Army Air Force. Italian art had a great effect on his work. He and Clare lived in Italy in 1958-59. Ross also studied at the New School for Social Research and had been an art professor at Manhattanville College in Purchase, NY, since 1964. He traveled to the American Southwest, Romania, Yugoslavia, Australia, New Zealand, Japan, and to the MacDowell Colony in New Hampshire, both to teach and make prints. Ross and Romano (also a printmaker) authored major books, one of which is *The Complete Collagraph* in 1980. They lived for a time in Cliffside Park and then in Englewood for many years. Ross's work is in the collections of the National Museum of American Art; Smithsonian Institution; Metropolitan Museum of Art; Library of Congress; New Jersey State Museum; Montclair Art Museum; Newark Museum; Princeton University Library Graphic Arts Collection; and others. Collagraph "Canyon" by Ross, courtesy of Robert Newman, The Old Print Shop, NYC.

CLARE ROMANO (1922-):

Romano was born in Palisade, NJ, to Italian-American parents, father an expert finisher of pianos and antiques for R. H. Macy, mother a music lover. Romano's art club excursions included painting waterfront barges in Edgewater, NJ, and visits to museums. Van Gogh, Thomas Hart Benton, and Rockwell Kent were among her early influences. As a Cooper Union student, she studied Bauhaus concepts, architectural and industrial design, photography, typography, and graphic arts. Her most influential teachers were Carol Harrison and Morris Kantor. At Cooper Union, Romano met John Ross (see page 28), whom she later married, with whom she lived for decades in Englewood. She also studied with Bauhaus artist Herbert Bayer, and worked as his studio assistant. When Ross returned from the military, the couple traveled to Europe. Under the auspices of the United States Information Agency (USIA), Romano and Ross served as artists-in-residence in Yugoslavia and Australia. After the birth of their two sons, Romano made lithographs, woodcuts, and etchings, taught at Pratt Institute, co-authored several books with Ross on printmaking, and illustrated children's books. *Continues on page 30.*

Continued from page 29:

Romano's art is in the permanent collections of MoMA; Whitney Museum of American Art; Metropolitan Museum of Art; Smithsonian Institution; National Museum of Art; New Jersey State Museum; Biblioteque Nationale in Paris; and others. *Above:* Collagraph "Tribute to New York City" by Ross, courtesy of Robert Newman, The Old Print Shop, NYC. *Right:* Romano's collagraph "Green Point Canyon," courtesy of Robert Newman, The Old Print Shop, NYC.

MARIE STURKEN (1922-): A graduate of Grand Central Art School, 1944, and Pratt Institute, 1946, and the Art Students League, Sturken began drawing sewing patterns for McCall's and working in the art department of Abraham & Strauss drawing newspaper ads. She was born in Danbury, CT, and raised in Stamford. Her father was a commercial artist and master printer for Conde Nast, and so influenced, Sturken eventually delved into printmaking, handmade paperworks, and fashion illustration. She and her husband, Robert, an engineer, and their three children went from Delaware to Westchester, NY, to New Brunswick, NJ, and finally to Princeton in 1962. Seven years later, she conducted the Princeton Graphic Workshop; with several workshops on print- and papermaking, lithography, and monotypes to follow. Sturken's work is in the collections of the New Jersey State Museum; Hunterdon Museum of Art; MoMA Library; Newark Library Print Collection; Firestone Library of Princeton University; and others. Sturken also worked at the Brodsky Center (Rutgers University) on a commissioned edition for the new hospital built by Capital Health System. *Above:* "New York Byzantinem" collagraph by Romano, courtesy of Robert Newman, The Old Print Shop, NYC. *Left:* Photograph of Marie Sturken courtesy of Judith K. Brodsky. *Upper left image:* "Byzantine," a collograph by Clare Romano, courtesy of Robert Newman, The Old Print Shop, NYC.

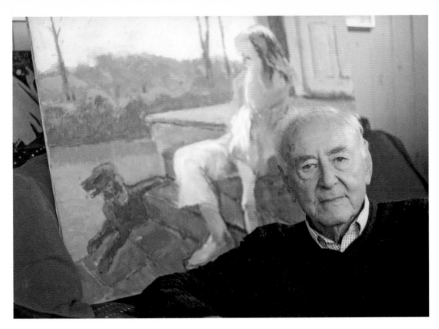

SANTO COSTANTE PEZZUTTI (1922-): A figurative painter trained at the Newark School of Fine and Industrial Arts, the Franklyn School of Professional Arts, and the Art Students League, Pezzutti first worked as an illustrator for the Newark advertising agency Charles Dallas Reach. Later, he worked in various advertising firms in New York City. He was art director of Paris & Pert and executive art director from 1958-78 at Dancer Fitzgerald Sample, NYC. He also served as art director of Smart Balance Foods (Cresskill, NJ). Pezzutti was born in Udine, Italy, and came to America at age five, when his stonemason father needed work and to provide opportunities for Santo and his siblings. *Above:* Santo Pezzutti and his painting "Lady with Black Dog." Photograph by Tova Navarra. *Below:* Pezzutti's "Vanessa at the Piano," oil on canvas, courtesy of Santo Pezzutti.

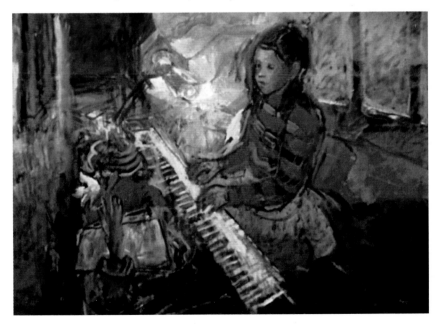

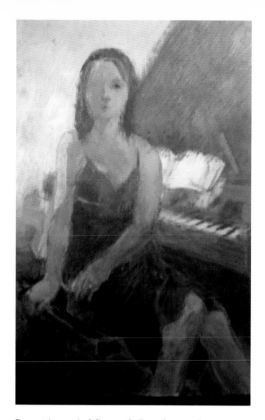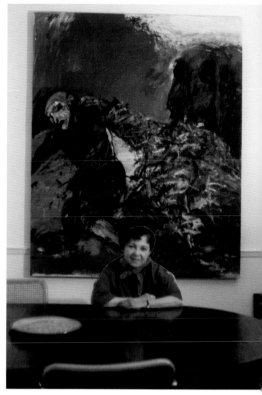

Pezzutti married Gertrude Dougherty, also an accomplished artist, and they had four children. He taught watercolor at the Summit Art Center in NJ in 1997. Among his solo exhibitions are Olympics Program, Atlanta, GA; Phoenix Gallery, NY; Monmouth University, and Carlmore Gallery, NY. He contributed watercolors and illustrations to books and is a member of the New Jersey Watercolor Society. A resident of Middletown and avid sailor, Pezzutti is also known for his paintings of boats and nautical themes. *Left:* "Girl at the Piano," by Pezzutti, photograph by Tova Navarra. *Right:* Miriam Beerman at her dining table in Upper Montclair. Photograph by Tova Navarra.

OPPOSITE PAGE:

MIRIAM BEERMAN (1923-): Beerman received the first one-woman exhibition in the history of the Brooklyn Museum in 1971. Her paintings, pastels, collages, ink drawings, woodcuts, lithographs, and monotypes are in the Whitney Museum of American Art; Newark Museum; Zimmerli Museum; New Jersey State Museum; Andrew Dickson White Museum, Cornell University; Morris Museum; Israel Museum in Jerusalem; and other public collections. Born in Providence, RI, her career began with studies at the Rhode Island School of Design, BFA, 1945, followed by studies with Morris Kantor and Yasuo Kuniyoshi at the Art Students League. Beerman continued at the New School for Social Research, eventually teaching painting and drawing before receiving a Fulbright Fellowship to study at the Paris Atelier 17 of William Stanley Hayter. Deeply affected by the Holocaust, the Vietnam War, and other tragic events, Beerman became an activist, a passion evident in her art. In 1959 she married American historian Julian F. Jaffe, with whom she had a son, William, in 1962. A year after the family moved to Upper Montclair, Julian died at age forty-three. In 1975 and for years after, Beerman received several fellowships, group and solo exhibitions, and awards, among them the 1988 Distinguished Artist Award from the New Jersey State Council on the Arts and a Book of the Year Award from the American Institute of Graphic Arts for the poetry anthology *The Enduring Beast*, which she edited and illustrated. She now resides in Maryland. *Opposite:* Beerman sits on the landing of the stairs in her home. Photograph by Tova Navarra

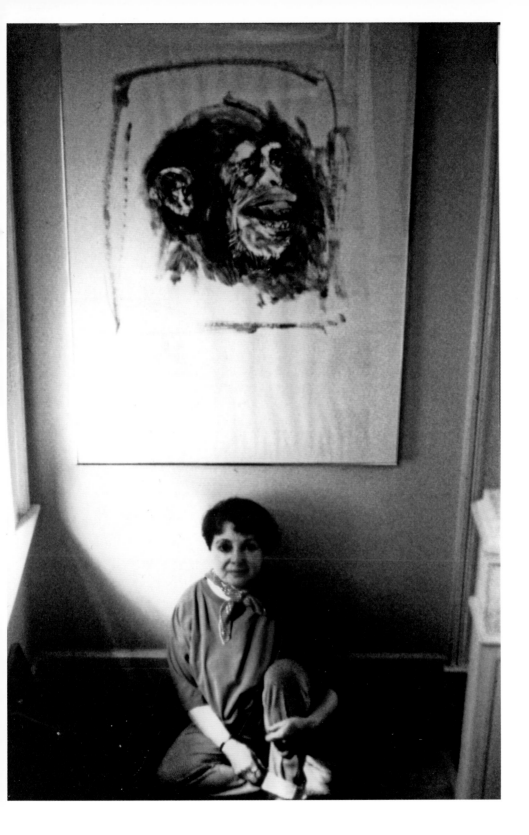

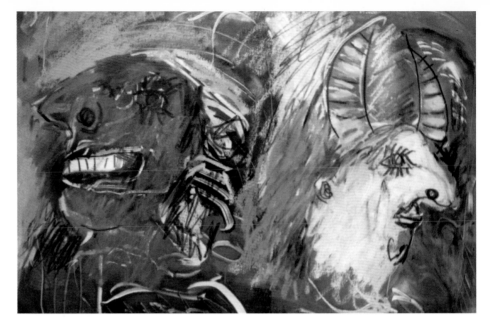

MIRIAM SCHAPIRO (1923-): Born in Toronto, Schapiro started painting at State University of Iowa and colleges in New York. She married artist Paul Brach in 1946, and in 1955 became a full-time artist, originally as an abstract expressionist. During the 1960s her commitment to feminism grew into her style she called "femmage." She established the Feminist Art Program at California Institute of the Arts, Valencia, CA, with artist Judy Chicago. In 1993 she collaborated with Rutgers Center for Innovative Printmaking (later named the Brodsky Center for Innovative Editions in 2006) to produce the first limited edition print to benefit the College Art Association's (CAA) newly established program of "Professional Development Fellowships." The initial print is titled "In the Land of Go-bla-dee: Homage to Mary Lou Williams," one of the earliest women jazz composers. Schapiro's work on Women Artists is in the Douglass Library at Rutgers University. She is noted for groundbreaking support of women's artistic freedom and the democratization of art, and her role in the establishment of the new art movement "Pattern and Decoration." In 2002 the CAA gave her the Distinguished Artist Award for Lifetime Achievement. *Above:* Beerman's pastel "Two Demons," from the collection of Tova Navarra. *Below:* Schapiro's "In the Land of Go-bla-dee," courtesy of Judith K. Brodsky.

GEORGE SEGAL (1924-2000):

Segal's parents, who ran a butcher shop in the Bronx and later a poultry farm in New Jersey, objected to his decision to become an artist. But Segal went on to be known worldwide as a painter and iconic Pop Art sculptor. He used plaster-imbued bandages, designed for making orthopedic casts, to wrap the people who served as the white-plaster, life-sized figures, which were then placed in various indoor and outdoor envi- rons. For example, Segal wrapped Israeli statesman Abba Eban to stand at the Abba Eban Center for the Diplomacy of Israel at the Hebrew University in Jerusalem. Born in the Bronx, Segal lived on a chicken farm in South Brunswick, NJ, from the 1950s until he died. He and his wife, Helen, had two children (Rena, their daughter, is a New Jersey artist of note), and the expansive chicken coop turned into Segal's studio. *Right:* George Segal in his studio with works in progress. Photograph by Tova Navarra. *Below:* Segal beside one of his iconic plaster figures. Photograph by Tova Navarra.

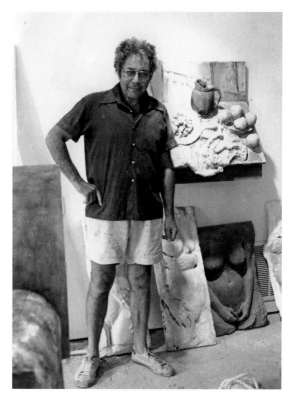

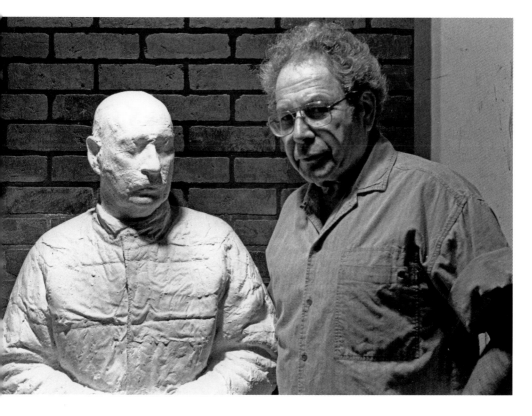

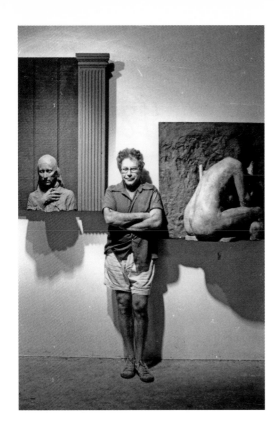

Educated at Pratt Institute, Cooper Union, and NYU (graduating 1949), he taught at Mason Gross School of the Arts, Rutgers, in addition producing commissioned works and exhibiting works in major American museums and many public places. He was awarded the National Medal of Honor 1999 for the three bronze sculptures for the FDR Memorial in Washington, DC. The George and Helen Segal Foundation, established in 2000, offers grants to artists and to see that Segal's art continues to be exhibited and donated to museums and galleries. *Left:* Segal stands between two sculptural paintings. Photograph by Tova Navarra. *Right:* A plaster figure in his studio. Photograph by Tova Navarra.

OPPOSITE PAGE:

JAMES KEARNS (1924-): Born in Scranton, PA, and now a resident of Dover, NJ, Kearns is a graduate of the Art Institute of Chicago and was an instructor of drawing, painting, and sculpture at the School of Visual Arts, NYC, from 1960 to 1990. He also taught at the Skowhegan School of Painting and Sculpture, Fairleigh Dickenson University, and other institutions. His numerous solo exhibitions include those at the New Jersey State Museum and the Sculpture Center, NY, and among his many principal exhibitions are the Whitney Museum of American Art, the Monmouth Museum, and the Pennsylvania Academy of Fine Arts. Kearns's critical references include "The Artwork of James Kearns" by Pamela Newton, *The Jung Journal*; "Art, Duty and Pleasure" by John Canaday, the *New York Times*; *Painting & Sculpture in New Jersey* by William H. Gerdts, Jr., and *The Figurative Tradition and the Whitney Museum of American Art* by the Whitney. His work is in the permanent collections of MoMA; the Whitney; Newark Museum; New Jersey State Museum; Montclair Art Museum; Butler Institute of American Art; Fogg Museum, Harvard University; the Smithsonian National Collection of Fine Arts; and others. Photograph of Kearns in his studio; "Tableau," and "Memorial" courtesy of James Kearns. "Memorial," oil on board by James Kearns, courtesy of James Kearns.

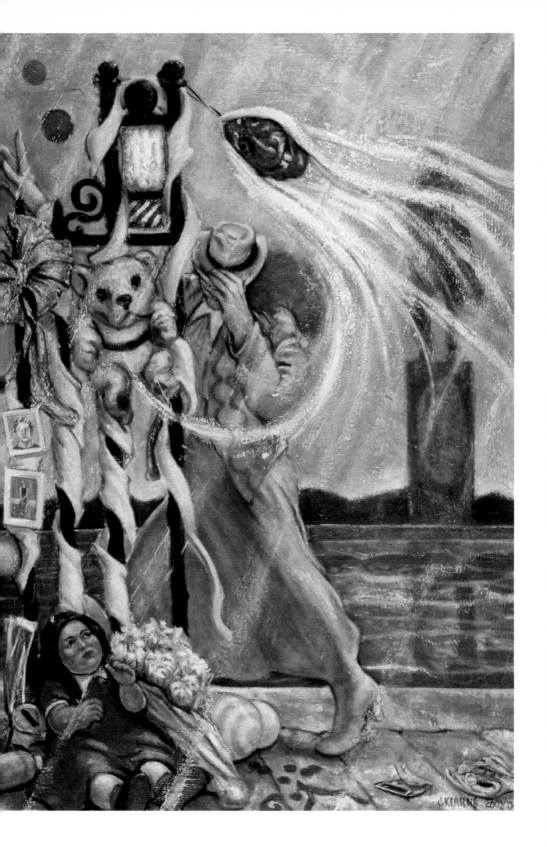

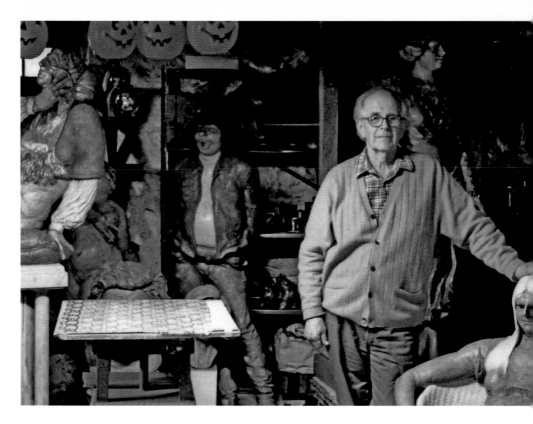

Above: Photograph of James Kearns by Peter Paone.

Left: "Untitled," by James Kearns, courtesy of James Kearns.

OPPOSITE PAGE:

EVELYN LEAVENS (1925-2013): Leavens was a stalwart of the Monmouth County art community and lifelong Red Bank, NJ, resident. Nicknamed "Eleven Lemons" by classmates of her youth, she was primarily a self-taught artist but attended the Vermont Studio Center in 1987 as a student of Malcolm Morley, Archie Rand, and Neil Welliver. Her first solo exhibition was at the Old Mill Gallery in Tinton Falls, which also introduced the work of artist Alice Neel and choreographer Martha Graham. In 1958 Leavens worked briefly at a veterinarian's office where she met a basset hound named Boswell. She made a series of humorous drawings of Boswell for her book published by Simon & Schuster titled *Boswell's Life of Boswell*, which was number

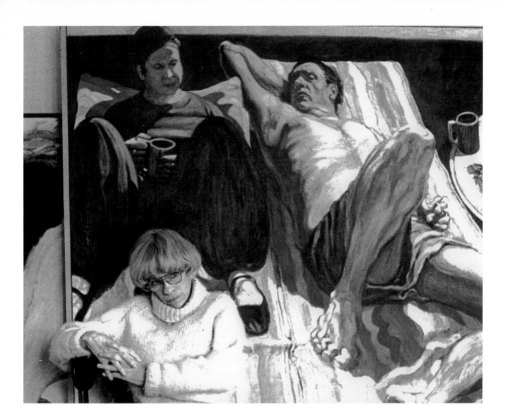

two on the New York Times Children's Best-Seller list, 1958. Being an artist was the only career Leavens said she wanted, having broken off an engagement she felt would have led to family responsibilities and thus hinder her career. Despite an early motorcycle accident that left her with a permanent spinal injury, Leavens worked consistently and later received two fellowships from the New Jersey State Council on the Arts. She was included in the Council's 1977 biennial at the New Jersey State Museum as well as in the Morris Museum; City without Walls; Aljira; Tweeds; and Summit Art Center. In 2010 the Monmouth Museum mounted the retrospective "The Painting World of Evelyn Leavens." *Above:* Evelyn Leavens in front of one of her large figurative works. Photograph by Tova Navarra. *Right:* Leavens in front of her self-portrait, photograph courtesy of James Yarosh.

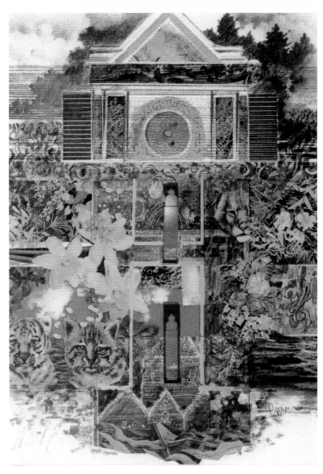

WERNER CARL BURGER (1925-): Karl and Helen Burger, of Pforzheim, Germany, left their home when their son, Werner Carl, was a year old. They left their country, newly defeated in World War I, and immigrated to Irvington, NJ. Unfortunately, the Great Depression took hold, which created financial difficulties for Karl, a jeweler. In 1944 the younger Burger was drafted into the Army and deployed to France just after the Allied D-Day invasion of June 6. He was transferred to Military Intelligence toward the end of the war, during which time he was part of a team that published a German-language newspaper for German citizens after the Nazis surrendered. Burger's career as an artist began with studying art at New York, Columbia, and Rutgers universities and at the Art Students League; he started as an abstract expressionist. With watercolors, collages, and drawings always in progress, Burger eventually became a professor of fine art at Newark State College, now Kean University, retiring as Professor Emeritus in 1993 after forty years. Kean awarded him membership in its prestigious Medallion Society. In 2012 the university mounted a retrospective "W. Carl Burger: Drawing for Fifty Years" in its Karl and Helen Burger Gallery. An unstoppable teacher, he served thereafter as visiting professor at several museums and art institutions. In 1960 Burger received the Bamberger Exhibition of Contemporary New Jersey Art Award, presented to him by French-American artist Marcel Duchamp. A resident of Califon, NJ, Burger continues to make art. His work has been exhibited throughout the United States: Lincoln Center; National Academy of Design, NY; Philadelphia Museum of Art; Montclair Art Museum; Smithsonian Institution; Newark Museum; New Jersey State Museum; and Morris Museum, as well as in corporate collections including British Airways, Warner Communications, AT&T;, Johnson & Johnson, and other venues. Burger's "Sunken Palace," drawing, watercolor, and collage, courtesy of W. Carl Burger.

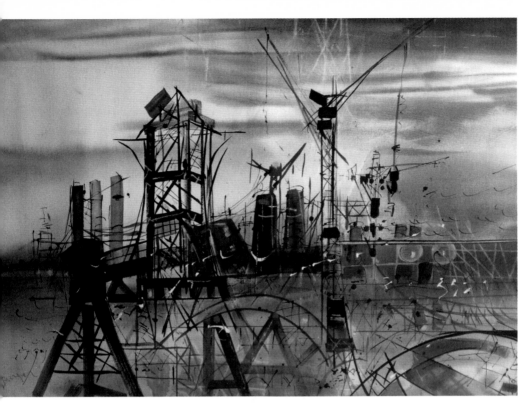

"Power Grids," painting by W. Carl Burger, courtesy of W. Carl Burger.

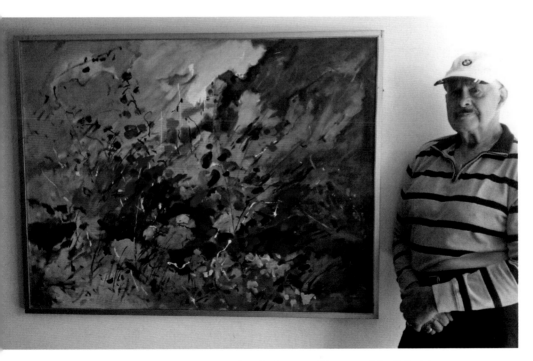

Burger with painting "Abstract," courtesy of W. Carl Burger. Photograph by Rafael Lopez.

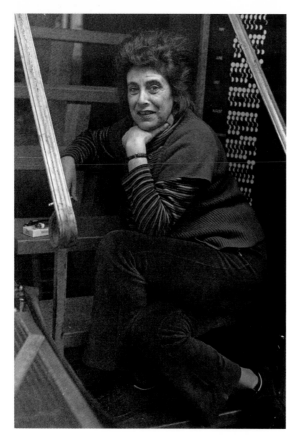

Naomi Savage (1927-2005):

Jersey City native Naomi Siegler was greatly influenced by her uncle, the famous Dada and Surrealist painter, sculptor, and photographer Man Ray (born Emmanuel Radnitsky), and she went from studying piano at Bennington College to pursuing photography. While a high-school student, she took a class taught by New York photographer Berenice Abbott at the New School for Social Research. Abbott had been Man Ray's assistant in the 1920s. Combining her interest in music and photography, Savage photographed famous composers and became her uncle's assistant in California. Married to artist and architect David Savage, she invented photographic engraving, which involves using the metal photographic plate as the art itself. Thanks to Man Ray's experimental work, Savage made topographic photographs with forms in three dimensions and with various metallic surfaces and tones. Her most famous photographic engraving is a magnesium mural that spans fifty feet on the side of the Lyndon B. Johnson Library and Museum, Austin, Texas. The subjects of the work are LBJ's elective offices and portraits of the presidents under whom he served. In 1952 Savage had her first exhibition at MoMA, where she exhibited three more times before her work became part of the museum's permanent collection. Her work is also in the Museum of Fine Arts in Boston; International Center of Photography in NYC; Art Institute of Chicago; Noyes Museum, Oceanville, NJ; and Fogg Museum at Harvard, among other institutions. In the years before she died in Princeton, she embraced digital photography and computer imaging. *Above:* Photograph of Naomi Savage by Tova Navarra. *Left:* Photo-engraving "Silhouette" by Naomi Savage, from the collection of Tova Navarra.

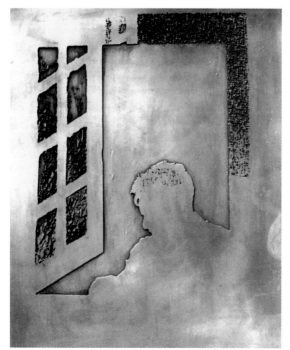

Opposite page:

Joan Hierholzer (1928-):

Best known for her landscapes, portraits, imaginative fantasy pieces, and images and murals of space and industry, Hierholzer was born in Grand Rapids, MI,

and for the past thirty years, she has lived in Pittstown, Hunterdon County, NJ. One of her Hunterdon County landscapes is on a three-paneled screen. Her "Microscopic Images" series, a foray into computer art, involved paintings based on magnified images of objects seen under a Carl Zeiss digital scanning electron microscope. A BFA graduate of the University of Texas, Austin, and an MFA graduate of Rutgers University, Hierholzer also studied at Raritan Community College and with portrait artists Robert Wilson and John Howard Sanden. Her work is in the collections of the Zimmerli Museum; Johnson & Johnson; Exxon Company, USA, Linden, NJ; Chemical Bank, NYC; Rutgers School of Law and Justice; NASA Gallery at the Kennedy Space Center, FL; Westinghouse Corp., Morristown, NJ; and many pharmaceutical companies and large corporations. *Right:* Photo-engraving "Ozymandias" by Naomi Savage, from the collection of Tova Navarra. *Below:* Photograph of Hierholzer with "Screen," courtesy of Joan Hierholzer.

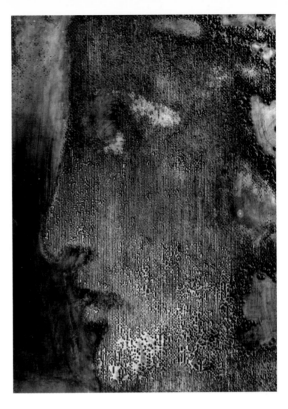

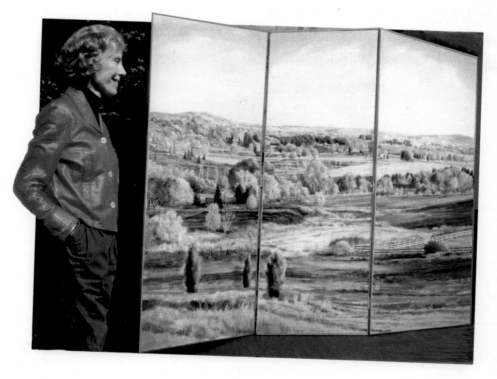

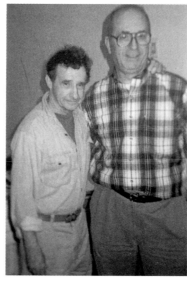

Far left:
"Two Birds" by John Goodyear, courtesy of Judith K. Brodsky.

Near left:
Photograph of Triano (left) with Edwin Havas at Seton Hall, from the collection of Tova Navarra.

(LEFT) JOHN GOODYEAR (1930-): Goodyear's earliest memory is of an earthquake that devastated southern California, where he was born. Ten years later, his father died and the family moved to Michigan to the home of his maternal grandparents. Goodyear studied art at the University of Michigan, Ann Arbor, where he met and married Anne Dixon. After earning his Master of Design degree, he was drafted into the Army and served two years in Japan. He was influenced by Japanese architecture and Zen Buddhism that characterized most of his work until he switched to three-dimensional painting. He taught at the University of Michigan in Grand Rapids until a grant from the Graham Foundation took him to the University of Massachusetts, where he worked on a grant project that became his first solo exhibition in NYC in 1964. Thereafter, he participated in more than fifty group shows throughout the nation with his art that dealt with light and movement. Goodyear also taught at Douglass College and Mason Gross School of the Arts at Rutgers University for thirty-three years. He replaced Roy Lichtenstein, who had just resigned. During the 1970s, he worked under fellowship on sculptures that featured inner heating at MIT's Center for Advanced Visual Studies. One of these sculptures was shown at the Whitney Annual, and at MIT he began a series titled "Earth Curve." Six of these pieces were shown at MoMA in 1972. His major public sculptures included his "Negative Figure" series. After retiring from Rutgers in 1997, Goodyear worked on a retrospective at the Michener Museum, Bucks County, PA, and he and his wife were co-curators of "Dada Country" at the Hunterdon Museum of Art near their home. They also curated "Iron Works," featuring artists who created works related to ironing, such as Man Ray and Marcel Duchamp. Goodyear's works are in the collections of MoMA; Whitney Museum of American Art; Guggenheim Museum; Metropolitan Museum of Art; Smithsonian Institution; and other collections in the US and Europe.

(RIGHT) ANTHONY THOMAS TRIANO (1928-1997): Painter, sculptor, illustrator, and educator, Triano concentrated on human and natural forms both figurative and abstract. In an autobiographical essay, Triano wrote of his interest in history, mythology, and art, which was inspired by sculptor Reuben Nakian. "His most valuable gift(s) to me were a total and passionate study of art of all ages, the importance of subject matter, a constant (*sic*) drawing style and the ultimate way of sculpting with terra cotta." Beginning in 1971 as artist-in-residence at Seton Hall University, Triano became a full-time professor in 1972 and taught there for twenty-five years. His work is in the collections of Newark Museum; Montclair Art Museum; Seton Hall University and Law School; William Paterson University; New York Lithographic Society; Lowe Museum in Coral Gables; Library of Congress; and Wuhan University in the People's Republic of China. Triano lived in Northern New Jersey.

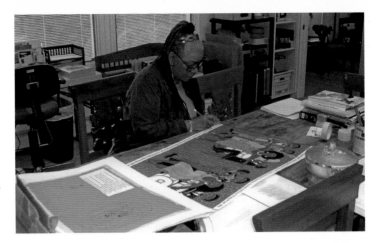

Photograph of Faith Ringgold at her desk, courtesy of Judith K. Brodsky.

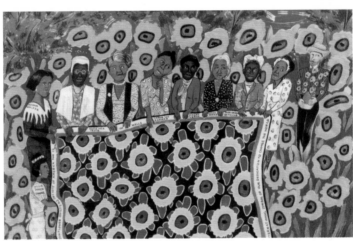

Ringgold's story quilt "The Quilting Bee at Arles" (copyright Faith Ringgold), courtesy of Faith Ringgold and Judith K. Brodsky.

FAITH RINGGOLD (1930-): An African-American artist born in Harlem, Ringgold (Faith Willi Jones) earned an MA at City College of New York and studied with Robert Gwathmey and Yasuo Kuniyoshi. She is Professor Emeritus at the University of California, San Diego. Ringgold – painter, writer, speaker, mixed-media sculptor, and performance artist – lives and works in Englewood. Her mother, Willi Posey, was a fashion designer who influenced Ringgold's painted story quilts. She is concerned about social issues including racial conflicts, hence her "American People" series portraying the Civil Rights Movement from a woman's point of view. The quilted artworks began in 1980, the first entitled "Echoes of Harlem." The quilts are modeled after the Buddhist Thangkas, pictures painted on quilted or brocaded fabric. Ringgold holds more than seventy-five awards, including twenty-two honorary Doctor of Fine Arts degrees. Among her many fellowships and grants are the National Endowment for the Arts Award for Sculpture, 1978, and for Painting, 1989, and the John Simon Guggenheim Memorial Foundation Fellowship for painting, 1987. Her art is in the collections of the Metropolitan Museum of Art; National Museum of American Art; MoMA; Guggenheim Museum; Newark Museum, and High Museum of Fine Art. Public commissions include "People Portraits," fifty-two mosaics in the Los Angeles Civic Center Subway Station, and "Flying Home: Harlem Heroes and Heroines," two twenty-five-foot mosaic murals in the 125th Street subway station, NYC. Her first book, *Tar Beach*, published by Random House, 1991, won more than thirty awards for the Best Illustrated Children's Book, including a Caldecott Honor and the Coretta Scott King Award. She also wrote her memoirs, and for *If a Bus Could Talk: The Story of Miss Rosa Parks*, she won the NAACP's Image Award, 2000.

SEWARD JOHNSON (1930-): Also known as J. Seward Johnson, Jr. and John Seward Johnson II, Johnson is best known for life-sized bronze statues made from castings of living people going about their daily activities. His trompe-l'oeil painted bronze statues are among his notoriously controversial work. A main objection to these works was that his work copied the iconic paintings by artists such as Manet and by famous photographs of events that won international recognition. Johnson's seventeen-ton sculpture of Marilyn Monroe standing over a subway grate was moved from Chicago to Palm Springs, CA, partly because of the controversy. The 2014 exhibit honoring Johnson at the Grounds for Sculpture (which he founded in Hamilton Township, NJ) will include the "Forever Marilyn" sculpture owned by The Sculpture Foundation. Born in New Brunswick, NJ, Johnson is the grandson of Robert Wood Johnson I, co-founder of Johnson & Johnson, and Colonel Thomas Melville Dill of Bermuda. He served four years in the Navy during the Korean War. He was married twice and has three children. He attended the Forman School and the University of Maine, where he majored in poultry husbandry, but did not graduate. Thereafter, he worked for Johnson & Johnson until he was fired by his uncle, Robert Wood Johnson II. *Continues on page 47.*

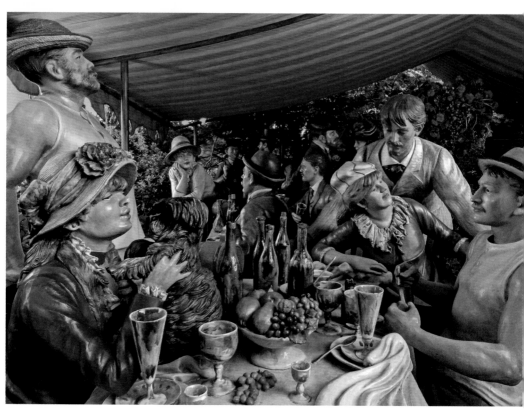

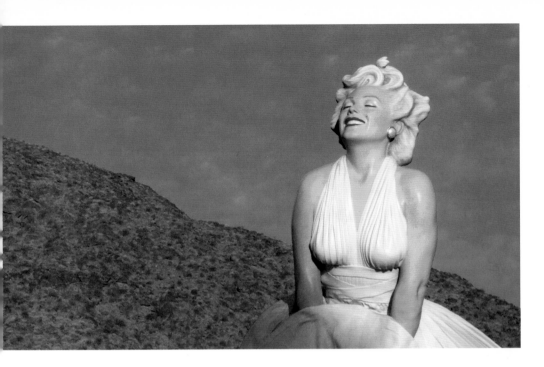

Continued from page 46:
Johnson's sculptures are on display in San
Diego; Key West; Snug Harbor, NY; and
Sarasota, FL, among other locations. A
Princeton resident for many years, Johnson
lives in Hopewell. *Left:* Seward Johnson
in front of "Unconditional Surrender" by
Seward Johnson Copyright 2004, 2005 The
Sculpture Foundation, Inc., photograph by
Carl Deal III. *Below:* "Were You Invited?"
by Seward Johnson Copyright 2001 The
Sculpture Foundation, Inc., www.sculpture
foundation.org, photograph by David W.
Steele.

JUDY DRAPER-MARTIN (1932-):

Educated at the Boston Museum School of
Fine Art, the Rhode Island School of Design,
and a BFA graduate of Pratt Institute, Martin
first worked freelance as a designer and illus-
trator. Her clients included publishers Little,
Brown; Random House; and Doubleday &
Company; and *Glamour, Charm, Seventeen*,
and *Parent's* magazines. Martin was born in
Norwood, MA, and in 1956 married Barry
M. Martin, who headed Barry M. Martin
Associates, Inc., a graphic design firm in
Rumson, NJ. In the early 1970s, she began
painting still-lifes and portraits of herself,

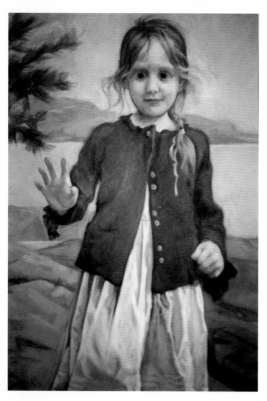

children, relatives, and friends in her Humanist style. She also taught figure and portrait painting at the Guild of Creative Art, Shrewsbury, and the Art Alliance of Monmouth County, Red Bank. Throughout the 1980s, Martin participated in state art exhibitions at the Monmouth Museum, (1987, juror Grace Glueck of the *New York Times*, and 1992, Zoltan Buki, curator, and Cynthia Sanford, director, of the New Jersey State Museum); Summit Art Center (1983, she won Best in Show, juror Judith K. Brodsky of Rutgers); and the New Jersey Center for Visual Arts (1988, juror David Pease, Dean of Painting at Yale University). Martin also exhibited repeatedly at the Kerygma Gallery, Ridgewood, and she won the Anna Hyatt Huntington Bronze Medal for painting from the Catharine Lorillard Wolfe Art Club, Inc., NYC, in 1991. In 1985 Martin exhibited in the New Jersey Biennial at the Newark Museum. A longtime resident of Red Bank, Martin lives and works in one of the houses on Washington Street, part of a well-known historic art district. *Page 47 upper image:* "Forever Marilyn" by Seward Johnson Copyright 1996, 2011 The Sculpture Foundation, Inc., photograph by Gregg Felsen. *Page 47 lower image:* Judy Martin at home standing next to a wall of her paintings. Photograph by Tova Navarra.

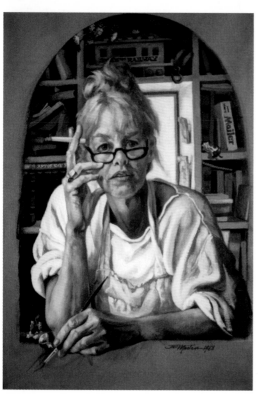

Above: Martin's portrait of her niece "Izzy," photograph by Tova Navarra.

Left: "Self-Portrait" by Judy Martin. Photograph by Tova Navarra.

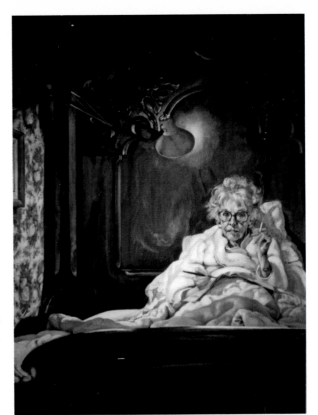

Right: Portrait of Martin's mother in her grand antique bed, photograph by Tova Navarra.

Below: Martin at the mantel with the painting "Elizabeth and Olivia" on it. Photograph by Tova Navarra.

JUDITH K. BRODSKY (1933-): Of ancestors who emigrated from the Ukraine in the 1880s, Brodsky's parents were teachers; her mother, Stella, taught home economics; her father, I. J. Kapstein, was a professor at Brown University, Providence, RI, where Judith grew up and eventually took classes at the Rhode Island School of Design. An MFA graduate of Harvard University; Distinguished Professor Emerita, Department of Visual Arts at Rutgers; and founding director of the Rutgers Center for Innovative Print and Paper (re-named the Brodsky Center in her honor); Brodsky has been a leader in the art world for the past three decades. She was married to David Brodsky while a student at Radcliffe, and they had two children. The family moved to Princeton in 1955. Judith and David had been married for forty-four years when David died at age sixty-seven. *Above:* "Wide Awake" by Brodsky, courtesy of Judith K. Brodsky. *Below:* Brodsky's print "Could Science Prove There's a God?" courtesy of Judith K. Brodsky.

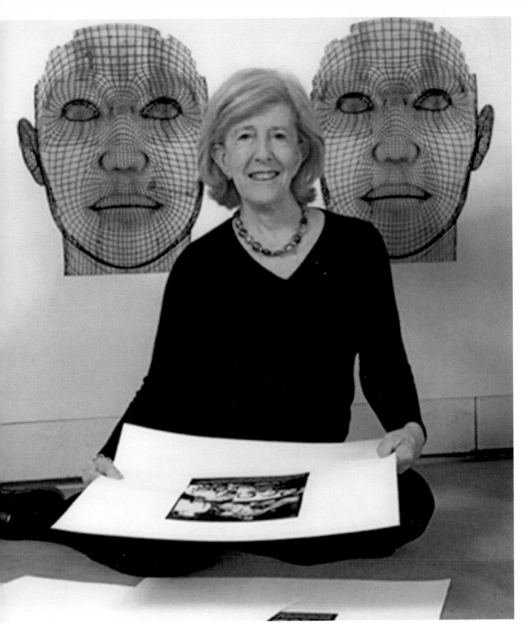

Brodsky later married Michael Curtis, an English-born professor of political science at Rutgers. She continued her work as master printmaker and women's advocate, particularly for making art about family history and autobiography. One of her major exhibitions was "Memoir of an Assimilated Family" at Rider University Art Gallery. She served as president of the Women's Caucus for Art (WCA) in 1976, past national president of ArtTable, and the College Art Association (CAA), established in 1972 to promote equity for women artists and arts professionals and today is one of the largest and most influential organization for women artists with twenty-seven chapters in the US. Brodsky was the first working artist to lead the CAA and expand political activism and membership in the WCA. She is also co-author of books on feminist art. Photograph of Brodsky in her studio, courtesy of Judith K. Brodsky.

RHODA YANOW (1933–): The Newark-born artist was taught how to draw by her grandmother, and her high-school art teacher helped her go to Parsons School of Design. After her second child was born, Yanow returned to her art education at the National Academy of Design, NYC, and exhibited her work and won many prestigious awards. Her art has influenced her children and grandchildren, as well as her students throughout her years as a teacher of figure painting and pastel at the duCret School of Art, Plainfield, NJ. Among Yanow's honors were those bestowed by the Allied Artists of America; Audubon Artists; Hunterdon Art Museum; Butler Institute of American Art; and Catharine Lorillard Wolfe Art Club. Her work is in the collections of the Newark Museum; National Art Museum of Sport; Noyes Museum; New Jersey Ballet Company; China Museum of Art, Suzhou, China; Prince Albert Museum, London; and in corporate and private collections. Yanow lives in Whitehouse Station, NJ. *Left:* Artist Rhoda Yanow, courtesy of Rhoda Yanow. *Below:* "Director— Hudson Valley" by Rhoda Yanow, courtesy of Rhoda Yanow.

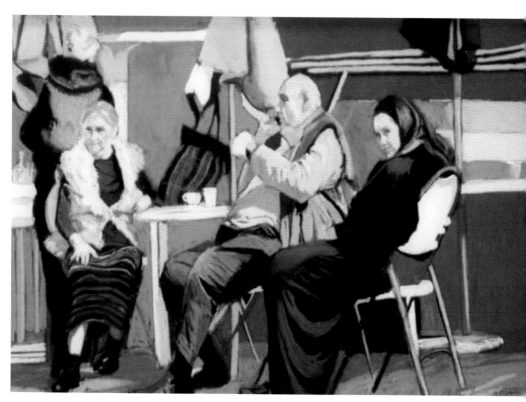

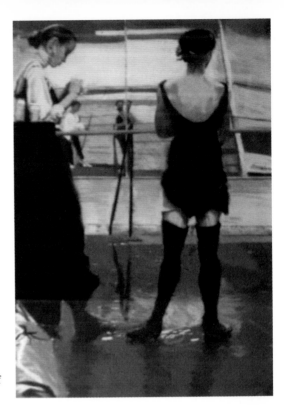

Yanow's "Black Stockings," pastel, courtesy of
Rhoda Yanow.

"Head Wrap," pastel by Yanow, courtesy of
Rhoda Yanow.

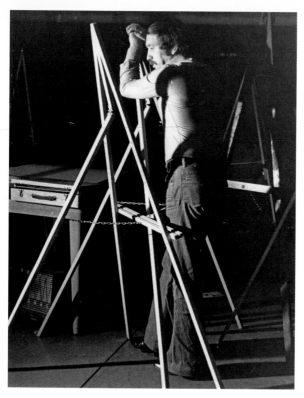

GIOVANNI MONTRONE (1933-2012):
In 1967, thirty-three-year-old Montrone
left Italy with his wife, Francesca, and
their three children to settle in West
New York, NJ. Born in Bitonto, seven
miles west of Bari, Montrone worked
for two years loading trucks for a
clothing factory until he could speak
enough English to move on to a better
job. He was a painter who, as a youth,
painted murals on any blank wall he
could find. His talent grew into what
he called "mindscapes" in his Fantasist
style, often emphasizing sociological
or political views. He detested visible
brushstrokes. In 1983 Montrone was
appointed Supervisor of the Recreation
Center of West New York, where he also
served on the Education and Library
boards and as Cultural Director of the
city. He taught and exhibited art at the
Art Center of the West New York Public
Library. He exhibited his own work
annually at the Greenwich Village Art
Show, NYC, and sold paintings to pri-
vate collectors. He also designed the
official logos of West New York, North
Bergen, and the Hoboken Housing
Authority. *Upper image:* Portrait of
Montrone in his studio, photograph by
Tova Navarra. *Lower image:* Montrone's
painting "The Effractors" (also called
"Lobbyism in Washington"), photograph
by Tova Navarra.

MICHAEL GRAVES (1934-2015): A painter before he was an architect, Graves was born in Indianapolis. He studied painting at the University of Cincinnati before studying architecture there, graduating in 1958. The next year he earned a master's degree in architecture from Harvard, after which he spent time in Italy, became a Fellow of the American Academy in Rome, and was awarded the Prix de Rome in 1960. Since then, Graves received numerous awards, fellowships, and citations for excellence. He joined the faculty of Princeton University as Professor of Architecture in 1962. Among his major building projects are the Rockefeller, Snyderman, Crooks, Bencerraf, and Alexander houses, as well as his own house in Princeton, and public buildings including the Sunar Furniture, Inc. showrooms in New York and throughout the US, and the Portland Public Office Building in Oregon. Graves also redesigned the master plan of the Newark Museum's entire museum complex, completed in 1989. Photograph of Michael Graves, Princeton, 1981, by Tova Navarra.

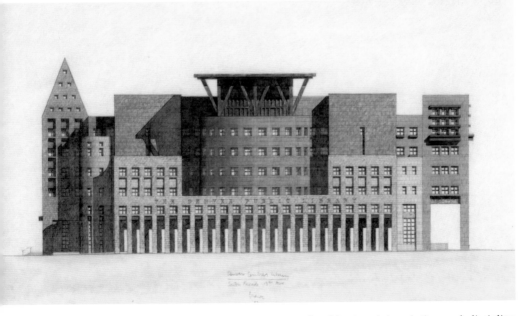

As a colorist, he incorporates painting into architecture and architecture into painting, each discipline adding greater dimension to the other. Hence Graves is renowned for his "hybrid" art and his diverse accomplishments as a designer. His work has been exhibited in and collected by numerous museums and galleries, including several exhibits at MoMA. A monograph of Graves's art was published by Rizzoli. A major show titled "Past as Prologue," set in the Grounds for Sculpture, Hamilton Township, NJ, celebrated the 50th anniversary of Graves's architectural firm and five decades of his work. Graves's drawing "Denver Central Library, South Façade," 1992, colored pencil on trace paper, courtesy of Michael Graves & Associates.

MEL LEIPZIG (1935-):

Born in Brooklyn, Leipzig lives in Trenton, NJ, where he is a professor of painting and art history at Mercer County Community Center. He has had more than forty solo shows, including those at museums and art centers in Arkansas, Florida, Georgia, Maryland, and New Jersey. He had a retrospective at the New Jersey State Museum in 1998. His works are in the collections of the Whitney Museum of American Art, the National Academy Museum and the Cooper-Hewitt Museum, NYC. In New Jersey his paintings are in the collections of the New Jersey State Museum; Montclair Art Museum; Morris Museum; Noyes Museum; Jane Voorhees Zimmerli Museum, Rutgers; and Jersey City Museum. In 2003 the American Academy of Arts and Letters purchased his painting of "Bernarda Shahn" and donated it to the Springville Museum of Art, Utah. In 2005 the Architectural Archives of the University of Pennsylvania purchased his painting "Robert Venturi and Denise Scott Brown." *Left:* Mel Leipzig in his studio with painting "Francesca at the Door," courtesy of Mel Leipzig.

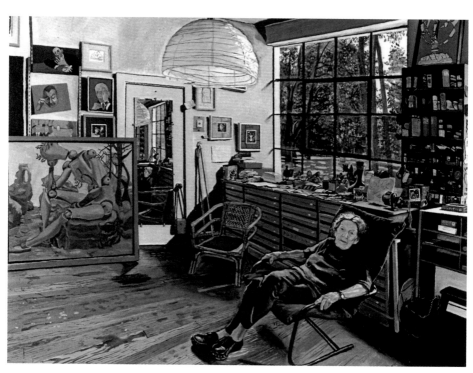

Leipzig received a Fulbright Grant to Paris, 1988-59; a Louis Comfort Tiffany Award, 1959-60; and four grants for painting from the New Jersey Council on the Arts, 1982, 1986, 1992, 2002. In 1980 he was the first recipient of the Mercer County Community College Distinguished Teacher Award, Gold Medal, and in 1996 was one of the last individual artists to receive a grant in painting from the National Endowment for the Arts. In 2000 and 2002 he received awards for his paintings from

the National Academy, NYC. He studied at Cooper Union under Nicholas Marsicano, Morris Kantor, Will Barnet, and Neil Welliver, 1953-56; Yale University School of Art & Architecture, BFA, under Josef Albers and James Brooks, 1956-58; and Pratt Institute, MFA, under Nan Benedict, Ralph Wickiser, and George McNeill, 1970-72. In 2006 Leipzig was elected to the National Academy. *Lower image page 56:* Painting of "Bernarda Shahn" by Mel Leipzig, courtesy of the Springville Museum of Art, Utah.

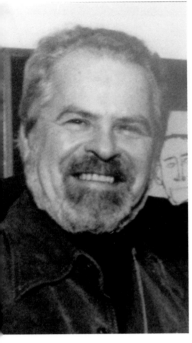 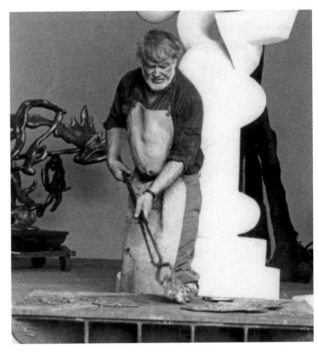

(LEFT) STEFAN MARTIN (1936-1994): The son of illustrator David Stone Martin and Thelma Durken Martin, a muralist and photographer, Martin was a graphic artist, wood engraver, painter, printmaker, and illustrator of Roosevelt, NJ. He drowned when his boat capsized in Assunpink Lake, Millstone Township. He earned a BFA from the Art Institute of Chicago, and his art was exhibited in many galleries and museums. Photograph of Stefan Martin, courtesy of Saliba Sarsar.

(RIGHT) ISAAC WITKIN (1936-2006): A sculptor taught by Sir Anthony Caro and other luminaries, Witkin was born in Johannesburg, South Africa. He attended St. Martin's School of Art, London, considered the most desirable school in England for the study of sculpture. Witkin also apprenticed in the early 1960s with British sculptor Henry Moore. At St. Martin's, Witkin and others were known as the "New Generation" sculptors of England. After his bold constructivist steel pieces brought him recognition, including first prize in the Paris Bienniale, Witkin taught at St. Martin's before working at Bennington College in Vermont with "the Green Mountain boys," such as Kenneth Noland, Jules Olitski, and Helen Frankenthaler. Witkin's piece "Nagas" was shown in "Primary Structures," a seminal exhibit of New Art, anchored by Caro in 1966 at the Jewish Museum, NY. In 1978 Witkin moved to New Jersey and became an artist-in-residence at the Johnson Atelier in Princeton. There he established his main sculptural style in bronze, and he persuaded sculptor J. Seward Johnson, Jr. to buy the former New Jersey Fairgrounds and create the Grounds for Sculpture in Hamilton Township. Witkin's sculptures are in the collections of the Smithsonian American Art Museum; Tate Gallery; Centre for Modern Art in Portugal; Fine Arts Museum of the University of Sydney, Australia; Israel Museum, Jerusalem; and other institutions and sculpture parks. He married and divorced Thelma Appel Johnson, with whom he had two daughters. A teacher at Parsons School of Design, Philadelphia College of Art, and Burlington County Community College in Pemberton, NJ. In 1987 he bought a twenty-two acre blueberry farm in Pemberton, where he died of a heart attack. Photograph of Isaac Witkin, courtesy of Nadine Witkin.

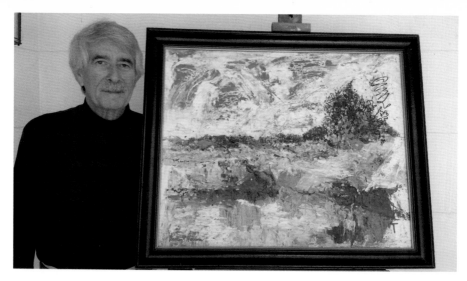

VINCENT J. NARDONE (1937-): Born in South Orange, Nardone is an artist/educator who taught in public schools for thirty years. He worked as an art specialist in the South Orange-Maplewood district, and studied creative problem-solving as a graduate student at the University of Southern California. Nardone also studied painting and art history in Paris and Florence. He is president of the Audubon Artists and vice-president of Allied Artists of America, and he is a former national nominating consultant to the *Biographical Encyclopedia of American Painters, Sculptors and Engravers.* Currently, Nardone serves as nominating consultant for *Who's Who in American Art.* A plein-air painter and visionary expressionist, he has had numerous solo and group exhibitions, including The Butler Institute of American Art; Noyes Museum; National Museum of Art in Budapest, Hungary; and he has received awards such as the Prix Rubens Medal in Painting from Queen Fabiola of Belgium, and the Silver Medallion in graphics from Seoul International Arts. Nardone, listed in *Who's Who of American Art 2014*, lives in Spring Lake. Photograph of Nardone and his painting "Jersey Shore Whimsy," exhibited at The Butler Institute of American Art National in 2011, courtesy of Vincent Nardone.

PAT STEIR (1938-): Steir is a painter and print-maker, born in Newark, who became known in the 1970s for her monochromatic canvases. She attended Pratt Institute for two years and then Boston University College of Fine Arts. She received a BFA from Pratt in 1962, a Distinguished Alumni Award from Boston University in 2001, and an honorary doctorate from Pratt in 1991. Steir's art was exhibited at the High Museum of Art, Atlanta, and MoMA before her first solo exhibition at the Terry Dintenfass Gallery, NYC, 1964. In the 1970s she was an illustrator and book designer and befriended conceptual artists including Sol Le Witt and Lawrence Weiner. She also had many exhibitions of her paintings, and her installation work

was shown at Documenta IX in Kassel, Germany, 1992, which established her as an important printmaker. The monograph *Pat Steir* was published in 1995 by American art critic Thomas McEvilley, and in 2008 she received the Pratt Institute Alumni Achievement Award. Steir's art is in the collections of MoMA; Metropolitan Museum of Art; National Gallery of Art, Washington, DC; Guggenheim Museum; Tate Gallery, London; and Whitney Museum of American Art. She lives and works in NYC. Portrait of Pat Steir by Greg Gaskey, courtesy of Pat Steir.

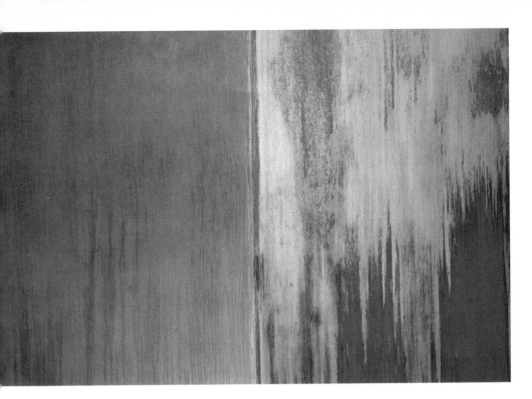

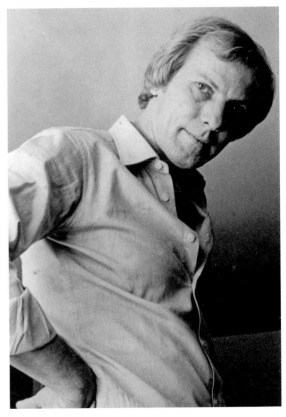

GEORGE A. TICE (1938-): Born in Newark, Tice is a tenth-generation New Jerseyan. He started work as a photographer's darkroom assistant for a Newark portrait studio. He went on to serve as a photographer's mate in the US Navy, during which time he photographed an explosion aboard the USS Wasp that caught the attention of the famed Edward Steichen, who bought the photograph for MoMA. Recognizing the artistic sensibilities of chronicling life experiences and images, Tice has produced more than seventeen books, such as *Hometowns: An American Pilgrimage*, *Lincoln*, *George Tice: Urban Landscapes*; *Paterson II*, and *Ticetown*, a book on Tice's ancestors. Considered a master printer, he was commissioned to print portfolios of Steichen, Edward Weston, Frederick H. Evans, and Francis Bruguiere. Tice's work is in the collections of MoMA; Metropolitan Museum of Art; Art Institute of Chicago; Biblioteque Nationale, and other institutions. In 1990 Tice had an exhibition at the National Museum of Photography, Film & Television in England.
Continues on page 60.

Continued from page 59:

A resident of Atlantic Highlands, NJ, Tice has received numerous fellowships and commissions, among them are the Guggenheim Foundation; Bradford Fellowship; NJSCA; and the National Endowment for the Arts (NEA). Tice received an honorary Doctorate of Humane Letters from William Paterson University. *Upper image:* Steir's "Green, Orange, and Mica," oil on canvas, courtesy of Pat Steir. *Lower image:* Photograph of George Tice by Tova Navarra.

SUSAN HOCKADAY (1938-): After graduating from Vassar College, Hockaday studied etching at Yale University and Pratt Graphics Center, NYC. She later studied photography at Princeton University and papermaking at the Haystack Mountain School of Crafts, as well as spending the 1986-87 academic year at the Museum of Fine Arts in Boston. During two sabbatical years with her family in Holland, she exhibited and worked at the Amsterdam Graphics Atelier. While living in England in 1982 and lecturing in China and Japan, she developed an interest in papermaking. In 1974 she was awarded the W. K. Rose Fellowship from Vassar College, Hockaday won fellowships from the New Jersey State Council on the Arts in 1982 and 1986. She has had more than twenty-five solo exhibits in NJ, NY, MA, and Nova Scotia, Canada. Her work is in many public and private collections, including the Princeton Art Museum. A Susan Hockaday abstract, courtesy of Judith K. Brodsky

JIM GARY (1939-2006):
Born James Theophilus Gary in Sebastian, FL, Gary is best known for his "Twentieth Century Dinosaurs," made from scrapped car parts welded together. Some of the pieces are more than sixty feet long and twenty feet high, and have been exhibited in museums, universities, films, dance, and musical presentations, and at car-racing, auto shows, and landscape events all over the world. Raised as one of eleven children in Colts Neck, NJ – father a mason and farmer, mother a domestic worker – Gary attended Freehold High School, did a stint in the US Navy where he trained as an aviation mechanic, and thereafter taught welding for the Job Corps. In the early 1970s, he used auto parts for a body of work combining science and art. The dinosaurs, sometimes referred to as "Garysauruses," went from outdoor art shows to Gary's first solo exhibition at the Academy of Natural Sciences in Philadelphia, 1979. Many solo shows later, he had a 1993 exhibit at the Tallahassee Museum. Also in 1993, Gary's pieces were exhibited at the Liberty Science Center for its gala opening. A 1984 exhibition throughout

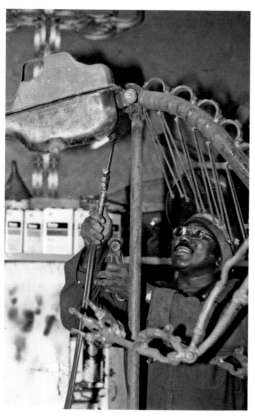

the Takashimaya Mall in Tokyo led to a six-month tour in Japanese cities. Gary also had an exhibition at the Smithsonian Institution's National Museum of Natural History, Washington, DC, 1990. Filmmaker George Lucas became aware of Gary's show at the California Academy of Sciences in San Francisco in 1985, and the next year he used the exhibition significantly in his film *Howard the Duck*. Gary's work traveled to Australia, China, and other countries, and photographs of his dinosaurs appeared in *National Geographic*, *Sculpture Review*, and *Smithsonian* magazines. Gary also made fine art sculptures such as "Universal Woman," made from metal washers welded together. The book *Jim Gary: His Life and Art* was written by this author, published in 1987 by HFN, Inc., NY. Gary lived in Farmingdale, NJ. Jim Gary welding in his studio in Hightstown, photograph by Tova Navarra.

EDWIN HAVAS (1939-): Known as a master watercolorist, Havas attended the Newark School of Fine and Industrial Art and was strongly influenced by painting teachers including Henry Gasser, Avery Johnson, James Carlin, and Hans Weingaertner. Havas was born in Orange, NJ, and he and his brother, Paul, also a gifted artist who died in 2012, grew up in Livingston, NJ. Havas did a three-year stint in the Air Force before he enrolled in art school. In 1956 he married Judith Moyles and started a family. Soon he began to teach at Seton Hall Preparatory School, then on the campus of Seton Hall University in South Orange. During his teaching career, Havas painted and exhibited his work, which earned him more than 100 awards, among them the Grand Prix pour Aquarelle in an international competition in Monaco, the New Jersey Watercolor Society's Silver Medal, and best-in-show prizes. *Above:* A "Twentieth Century Dinosaur" by Jim Gary, photograph by Tova Navarra. *Right:* Edwin Havas on stairs, photograph by Tova Navarra.

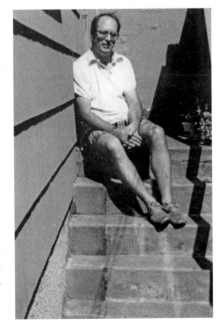

For his mastery of landscape painting which made up a great body of work, he also became a member of the American Watercolor Society. In addition, he served as member and past president of the New Jersey Watercolor Society. Havas taught at the Prep and the university for twenty-five years and retired in 1975, when the Edwin J. Havas Medallion for Excellence in Art was established. This award is given each year to a graduating senior student. Havas and his wife moved to Bethlehem, PA, many years ago where he continued to be a prolific artist and, with wife Judy's assistance, conductor of numerous watercolor workshops locally and in Ireland and Italy. In Bethlehem he was commissioned by the Historic Bethlehem Partnership to paint the Moravian Waterworks as it may have looked 250 years ago. This oil painting was also used as a Christmas card for the city of Bethlehem in 2010. *Left:* "Frost Valley Falls," by Havas, courtesy of Edwin Havas. *Below:* Havas's painting "Along the Delaware," courtesy of Edwin Havas.

ROBERT RICHARD TOTH (1939-): Sculptor, painter, and designer, Toth was born and raised in Newark and is a graduate of the Newark School of Fine and Industrial Arts. He did post-graduate studies at the Art Students League and the Cape School of Art with Henry Hensche in Provincetown, MA. He worked as a designer for Congoleum Industries, and in 1935, he established the Island Heights Studio of Art, NJ, and RT-DESIGNS USA, now in North Carolina, where he lives with his wife, Lee. The two met in art school and married in 1976. Toth has completed nearly 100 instructional television programs, among them *Art & Creativity* and *The Realm of Art*. His work includes exhibitions at venues such as the Metropolitan Opera in NYC; commissions by Lincoln Center for the Performing Arts, MGM Studios, 20th-Century Fox, Miramax, Showtime, and NBC; and collection purchases by museums including the National Portrait Gallery, Washington, DC, Royal Scottish Museum, Edinburgh, Scotland, and Vatican Museum, Rome. Toth's art is also in the collections of Albert Einstein College of Medicine; the Pentagon; and The Nation's Capital, Washington, DC. *Above:* "Sagit Snowmelt" by Paul Havas, courtesy of Edwin Havas. *Below:* Photograph of Robert Toth with one of his sculpted plaques, collection of Tova Navarra.

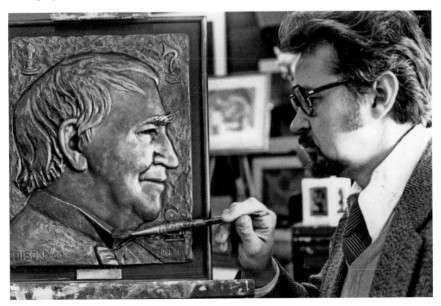

MIKLOS L. SEBEK (1941-): Born in Soskut (fifteen miles from Budapest), Hungary, Sebek studied sculpture at the State Atelier of Fine Arts and in the evenings studied at the Ybl Miklos Technical Institute of Architecture in Budapest. In 1969 studied the Renaissance style in Italy, where he spent several months. He defected in 1970 and immigrated to the US, where he majored in fine arts at Montclair State University with Professor Brian Watkins. In 1976 he became a full-time artist and sculptor. He was an instructor from 1990 and is presently teaching sculpture at the Rutherford Adult School and Bergen Community College. He works in marble, bronze, stainless steel, wood and welded metal. His work has been exhibited at the New York National Academy; National Arts Club, NYC; Salmagundi Club, NYC; Morris Museum; Noyes Museum; Art Expo, NYC; and in several arts centers and galleries nationwide. His work can also be found in museums, public places, corporate and private collections in the US, Hungary, Italy, Japan, Australia, Germany, Canada, and England. He is an honorary member, vice president, and exhibition chairman of the Audubon Artists Inc., NY, and a member and exhibition chairman of the Allied Artists of America. Sebek is also listed in *Who's Who in American Art* and *Biographical Encyclopedia of American Painters, Sculptors & Engravers of the USA*. Sebek has lived in Passaic, NJ, for more than twenty-five years. *Above:* Toth alongside his sculptures, courtesy of Robert Toth. *Right:* Photograph of sculptor Miklos Sebek, courtesy of Miklos Sebek.

DAVID JOHN RUSH (1943-): Born in New Jersey, Rush is a graduate of the Famous Artist School in Connecticut, where his instructors included Norman Rockwell, Albert Dome, Peter Helk, Rudi Derenea. Now a resident of Sussex County, he graduated from the Newark School of Fine and Industrial Art with a BA, and received his teaching certification from Maryland Institute College of Art. He taught at the Newark School from 1965 to 1971 after teaching at Montclair State University; William Paterson University; The Kubert School of Cartooning and Graphic Art; and Sussex County Community College, where he was head of the Graphic Design Department and co-chair of the Fine Art Department. He has had seven museum shows and more than 100 (mostly solo) gallery shows. *Right:* "Quartet," marble, by Miklos Sebek. *Below:* Photograph of Rush with "Constellation," oil on canvas, courtesy of David Rush.

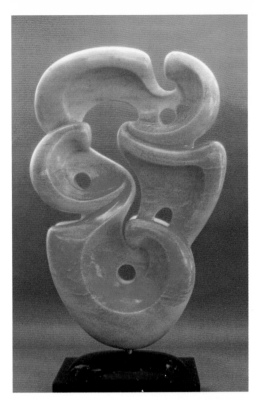

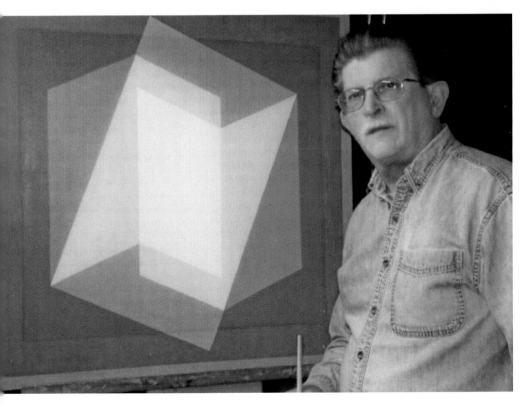

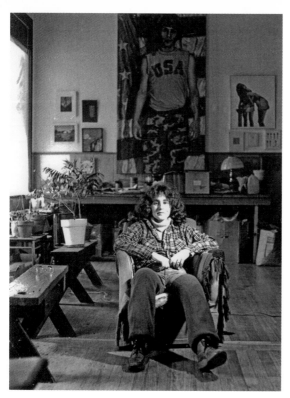

GRACE GRAUPE-PILLARD (DATE OF BIRTH WITHHELD-): The daughter of a dressmaker/designer and an architect who greatly influenced her, Graupe-Pillard was born in Washington Heights, NYC. She is known as a staunch feminist and anti-ageist. As a twin to her sister Florence, she is also influenced by issues concerning individuality. Graupe-Pillard went to the High School of Music and Art and City College of New York, where she earned a bachelor's degree in political science and history. She left her post-graduate work in Russian Area Studies at CUNY in order to attend the Art Students League to study drawing with Marshal Glasier. She lived in New Mexico for six years, where she met and married Stephen Pillard. From New Mexico she moved to New Jersey. Her work emphasizes strong political and sociological points of view. From 1990 to 1993, Graupe-Pillard created an exhibit dealing with the destructive effects of power titled "Nowhere To Go: One Family's Experience," shown at the New Jersey State Museum. Her series of large

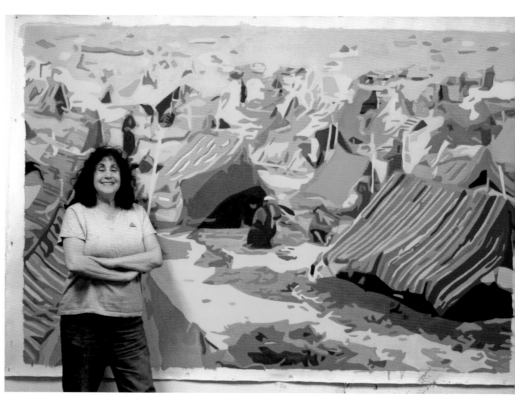

paintings titled "The Holocaust: Massacre of Innocents" was exhibited at Rider University. She has exhibited throughout the US in venues including the New Jersey State and Noyes museums and many prestigious galleries, and she received grants from the New Jersey State Council on the Arts and the National Endowment for the Arts. Appointed a Visual Arts Panelist for the New York State Council on the Arts, Graupe-Pillard served on NJ Transit's Art Committee to help develop a master plan for the inclusion of art in the Hudson-Bergen Light Rail Transit System. From 2003 to 2010, she was coordinator of the Edwin Austin Abbey Mural Workshop. She maintains Keyport, NJ, and Manhattan addresses and currently works in NYC. *Upper image:* Grace Graupe-Pillard in her Red Bank studio, c. 1980s. Photograph by Tova Navarra. *Lower image:* Photograph of Graupe-Pillard in front of her painting "Shelter," oil/alkyd on canvas, courtesy of Grace Graupe-Pillard.

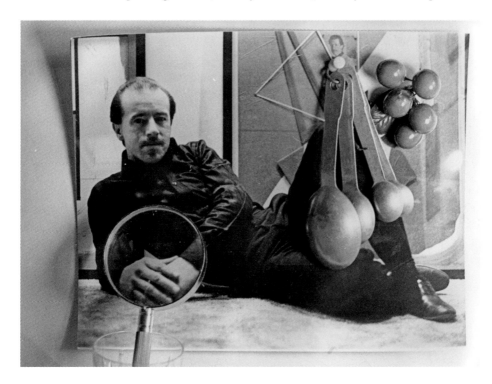

GARY T. ERBE (1944-): A self-taught painter born in Union City, NJ, Erbe maintained his studio there from 1972 to 2006. He worked as an engraver from 1965 to 1970 to support himself and his family, and painted nights and weekends. After being influenced by trompe-l'oeil masters in 1967, Erbe later created a more contemporary style he dubbed "Levitational Realism," a departure from 19th century trompe-l'oeil. *Above:* Faux-trompe-l'oeil photograph of Gary T. Erbe, c. 1981, by Tova Navarra. *Right:* "Fantasy in Pursuit," oil painting by Erbe, courtesy of Gary T. Erbe.

Erbe has had solo exhibitions at museums and galleries throughout the US, Asia and Europe since 1970, and was invited into many important exhibitions in the US and abroad including "Outward Bound – American Art on the Brink of the 21st Century," organized by Meridian International Center in Washington, DC, which traveled throughout the Far East. His work was also represented in "American Realism," which opened September 2012 at The Beijing World Museum in China and traveled to five museums in China for more than a year and a half. Erbe's awards and honors include an unprecedented six Gold Medals from the Allied Artists of America, Inc., Annual Exhibitions held at the National Arts Club, NYC. He also received the Medal for Lifetime Achievement in American Art from the Butler Institute of American Art, OH; Salmagundi Club Medal of Honor, NYC; Gold Medal from the National Museum of Sports, IN; first prize from the National Arts Club, NYC; and Gold Medal of Honor from Audubon Artists, NYC. Honored with a twenty-five-year traveling retrospective in 1995 and a forty-year traveling retrospective in 201, Erbe maintains his studio in Nutley, NJ. "Double Image" by Erbe, courtesy of Gary T. Erbe.

VINCENT DiMattio (1941-):

Influenced early in his career by Modigliani, Matisse, and Klee, DiMattio works in several mediums and in diverse modern styles. He earned a BFA from the Massachusetts College of Art, and an MFA from Southern Illinois University. Born in Quincy, MA, he went on to exhibit throughout the US; in Madrid at the Centro Cultural de los Estados Unidos; the Capitolio, San Juan, Puerto Rico; Pueblo, Mexico; and in NYC's 101 Wooster Street and Susan Berke galleries, the latter for his first NYC retrospective. DiMattio began his extensive teaching career at Southern Illinois University, and then at the University of Wisconsin, Milwaukee. In 1968-69 he joined the Monmouth University faculty and rose to professor of art, department chair, and gallery directory. *Right:* "Guitar" by Erbe, courtesy of Gary T. Erbe. *Below:* Photograph of Vincent DiMattio in his studio, photograph by Tova Navarra.

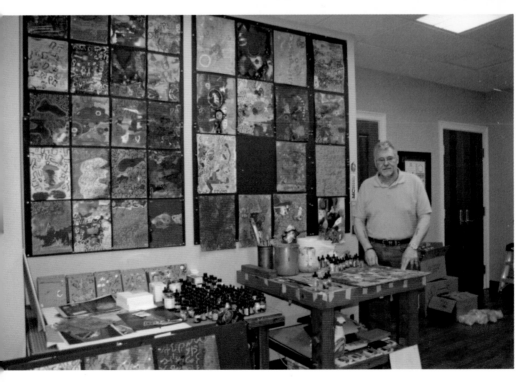

He is largely responsible for establishing the university's gallery program; in 2013, the main gallery of the new Rechnitz Hall for the Department of Art and Design was named The DiMattio Gallery. In 1999 his thirty-year Monmouth Retrospective Exhibition was comprised of nearly 200 pieces. DiMattio co-authored the book *The Drawings and Watercolors of Lewis Mumford*, Edwin Mellon Press, 2004, with his colleague Kenneth Stunkel. The next year he received a $10,000 grant from the Liquitex Paint Company for the completion of more than sixty "tube paintings," exhibited at the university and at Brookdale Community College. The father of three, DiMattio lives with his wife, Deborah, in Loch Arbour, NJ.

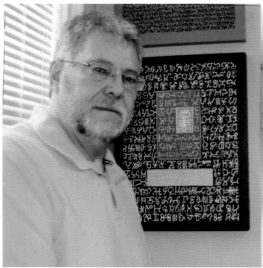

Above: DiMattio and his artwork including "Circle," photograph by Tova Navarra.

Left: "Rain" painting by DiMattio, photograph by Tova Navarra.

BRIAN LAV (1945-): Born in Newark, Lav was nine when a Kodak darkroom kit given to him by his parents planted the seed of what would become his life's passion. His formal training began with Lou Bernstein, an old "Photo-Leaguer," who taught a weekly workshop in Manhattan. In 1969 he earned a degree in economics without a desire to pursue a career in business. In 1972 he traveled to the West Coast to study with masters Bret Weston, Morley Baer, and Paul Caponigro. In 1974 he was invited by Ben Fernandez to join the staff of Parsons the New School for Design, NYC, and Lav has been a professor of photography ever since. In 1998 he received its Distinguished Teaching Award. In 2002 Amherst Media published Lav's textbook *Zone System*, a precise system of exposing and developing black-and-white film, currently used by several universities and is in the collection of many libraries. He taught at Drew University, Madison, NJ, from 2003 to 2009, and the following year published *Brian Lav Photographs 1969-2009*, a collection of fifty-nine of his photographs. *Continues on page 72.*

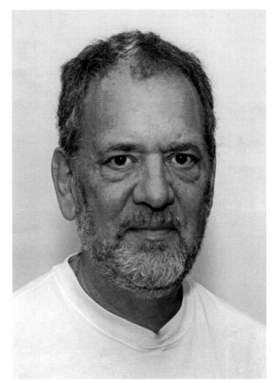

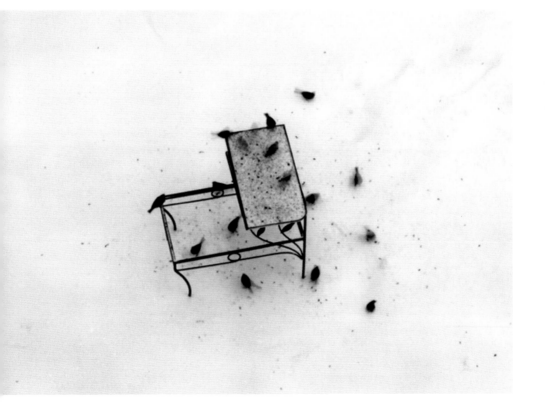

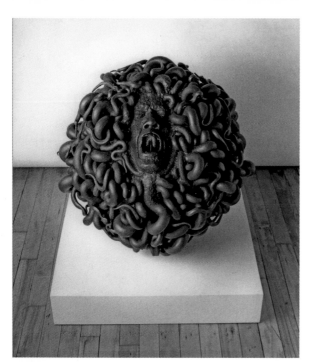

Continued from page 71:
He published *Along the Jersey Shore*, a collection of photographs documenting the uniqueness of one of New Jersey's treasures, and *Visions*, a forty-year retrospective of his analog black-and-white photographs. He is currently working on a photo-essay, "On the Road," depicting a road trip across the US. To date, he has had more than forty solo and group exhibits, and his work is represented in many permanent collections. *Upper image:* Portrait of Brian Lav, courtesy of Brian Lav. *Lower image:* Lav's photograph "Birds in Snow," courtesy of Brian Lav.

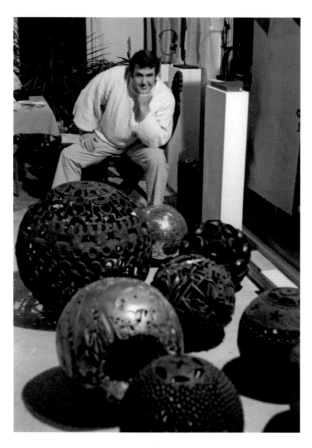

MICHAEL MALPASS (1946-1991):
Born in Yonkers, NY, Malpass studied with influential sculptors such as Alberto Giacometti at Pratt Institute, where he later taught. He was a printmaker who took up sculpture. He earned an MS and was working for an MFA when he was inducted into the US Army during the Vietnam War. Determined to make art while stationed in Berlin, Germany, Malpass used oil paint on old canvas Army tents. He returned home and completed an MFA while serving as Professor of Welding and Forge at Pratt. In 1997 he had his first solo exhibition at the Betty Parsons Gallery, NYC, and his sculptures – particularly spheres made of found metal objects and a series he called "Chickenmen" – became known to the art media. During the 1980s he produced hundreds of pieces. *Above:* "Screaming Medusa" sphere by Malpass, photograph by James Rudnick, courtesy of Cathleen Malpass. *Left:* Photograph of Michael Malpass with spheres, by Tova Navarra.

A resident of Brick, NJ, with his wife, Cathleen, and their children, Malpass also accepted commissions including those from General Electric and the states of New Jersey and Connecticut, on which he was working the year before he died. Among the many venues that acquired his work are the Ford Foundation; Rutgers University; National Art Museum, Sofia, Bulgaria; National Museum of Art, Warsaw, Poland; Mint Museum, Charlotte, NC; and Oklahoma Art Museum, Oklahoma City, OK. *Right:* Malpass with "Newtonian Sphere," photograph by James Rudnick, courtesy of Cathleen Malpass.

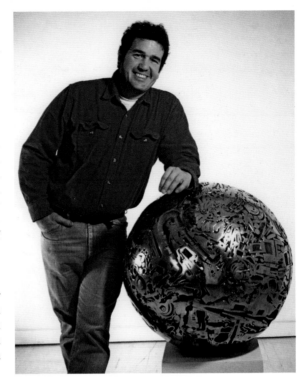

(**BELOW**) MIKE QUON (1947-): The son of a Walt Disney animator for films such as *Fantasia* and *Dumbo* and a devotee of the Pop Art movement, Quon grew up in Southern California and is a graduate of UCLA. There he studied with Richard Diebenkorn and Ed Ruscha.

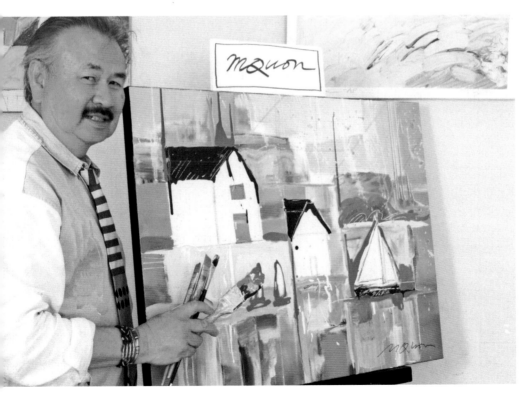

Photograph of Quon with paintings, courtesy of Mike Quon.

Of Chinese heritage, Quon started his career as a graphic artist influenced by California's bright colors and by the art of Matisse and Dufy. In the 1970s, Quon moved to New York City and worked in acrylics, watercolors, oil pastels, color pencil art sticks and gouache. In New York in 1997, he began to accept large commission projects. He also traveled with his sketch books, which led to art exhibitions in Asia, Europe, South America, and throughout the US, and gallery and museum exhibitions in New York, Los Angeles, and Paris. His work is in the collections of the Library of Congress; US Air Force Art Collection; New York Historical Society; and the *New York Times*. After thirty years working in New York, Quon relocated to the Red Bank area. He is also the author of two books, *Non-Traditional Design* and *Corporate Graphics*, both published by PBC International. Quon and his family live in Fair Haven. His father is 101 years old and still painting and drawing in Los Angeles. *Above:* "Dog," one of Quon's series of the Chinese Zodiac, courtesy of Mike Quon. *Below:* Watercolor painting of buildings by Quon, courtesy of Mike Quon.

Quon's painting "Chrysler Building," courtesy of Mike Quon.

KENNETH HARI (1947-): A painter and sculptor best known for his portraits of famous actors, authors, musicians, scientists, and other celebrities, Hari was born in Perth Amboy, NJ, to a family that moved frequently, including to California, and attended one school with Dustin Hoffman. Hari's parents had a house in Key West, where Hari swam in Tennessee Williams's pool and wrote art criticism for Key West newspapers. A graduate of the Newark School of Fine and Industrial Arts, 1966, he earned a BFA from Maryland Institute College of Art, 1968, attended Yale University, 1970, and did post-graduate work at New York University, 1988. "The Pearl Earring" by Hari, courtesy of Kenneth Hari.

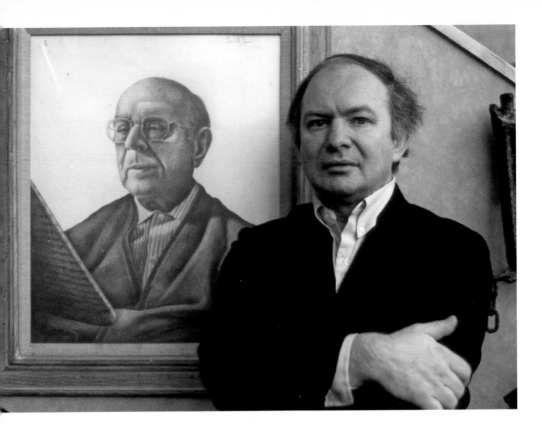

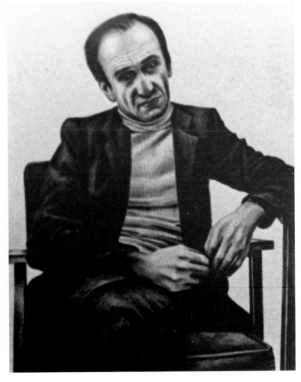

Among his more than 290 portraits from sittings are those of W. H. Auden; Groucho Marx; Giorgio de Chirico; Salvador Dali; Ernest Hemingway; H. W. Janson (of *Janson's History of Art*); Greta Garbo; Dr. Linus Pauling; Robert Motherwell; Dolly Parton; Lauren Bacall; Aaron Copland; Isaac Asimov; George Balanchine; Dustin Hoffman; Lewis Mumford; James A. Michener; Helen Keller; James Earl Jones; Gore Vidal; Louis Nizer; Otto Preminger; and Gene Kelly. Hari's work is in the permanent collections of more than 350 museums, including Newark Museum; Beijing Museum of Fine Arts, China; Vatican Museum; Metropolitan Museum of Art; New Jersey State Museum; Grand Ol' Opry House, Nashville, TN; Lincoln Center Gallery, NYC; and Virginia Polytechnic Institute, Blacksburg, VA. Hari and his wife, Xiaoyi Liu, live in Hopelawn. *Above:* Photograph of Hari with his portrait of Pablo Casals by Tova Navarra. *Right:* Hari's portrait of Elie Wiesel, courtesy of Kenneth Hari.

BOB MATARANGLO (1947-): Born in South Amboy, NJ, Mataranglo holds a master's degree in painting from Montclair State University, an MFA in visual arts from Vermont College, and degrees in engineering. He is co-founder of Black Box in Asbury Park, and co-founder and past vice-president of the Shore Institute of Contemporary Art (SICA) in Long Branch. Mataranglo's work includes nearly 200 murals, hundreds of three-dimensional works, award-winning animations, and numerous outdoor sculptures. He lives in Lakewood. *Left:* Photograph of Bob Mataranglo with the guitar he created for the City of Belmar, courtesy of Bob Mataranglo. *Below:* Portrait of Mataranglo by Danny Sanchez, courtesy of Bob Mataranglo.

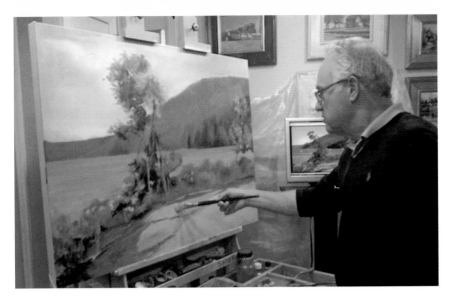

ANTHONY MIGLIACCIO (1948-): An established printmaker and painter, Migliaccio has exhibited his work extensively since the early 1970s. He is listed in *Who's Who in American Art* and holds a BA from the College of New Jersey and an MA in Art Education from Kean University. He is a recipient of a Geraldine R. Dodge Painting Fellowship and has received several awards for his paintings, including a first-place award at the Bayonet Farms Art and Music Festival, the Guild of Creative Art Open Juried Show, two awards at the Audubon Artists National Open Juried Show, and the Monmouth Museum Open Juried Show. Born in Long Branch, Migliaccio is an Exhibiting Artist Member of the Audubon Artists, NYC, and of the Guild of Creative Art, and he is a Signature Artist Member of the Noyes Museum and the Plein-Air Painters of the Jersey Coast. An associate member of Oil Painters of America, Migliaccio has had several solo exhibitions at the Noyes Museum and has exhibited in more than 100 open juried shows. He retired as an arts administrator in New Jersey public schools. The parents of two grown daughters, Migliaccio and his wife, Dee, live in Long Branch, NJ. *Above:* Photograph of Anthony Migliaccio in his studio, courtesy of Anthony Migliaccio. *Below:* Oil painting "Hidden Beach, Sandy Hook," courtesy of Anthony Migliaccio.

LONNI SUE JOHNSON (1950-): Johnson worked as an artist, illustrator, musician, pilot, and farmer whose career spanned thirty-one years before she suffered profound amnesia after a nearly fatal battle with encephalitis in 2007. The disease destroyed her hippocampus, wiping out most of her old memories including a ten-year marriage, as well as her brain's ability to form new ones. Her art is characterized as playful, bright-hued, and often complex, and has appeared in publications such as on several covers of the *New Yorker*, children's books, murder mysteries, a physics textbook, and the *New York Times*. In 2011, her sister, Aline Johnson, co-curated *Puzzles of the Brain: An Artist's Journey Through Amnesia*, a show of her sister's drawings at the Walters Art Museum, Baltimore. The exhibit included drawings Johnson made before and after her memory was destroyed, along with documents from a continuing case study undertaken by a Johns Hopkins University team led by neuroscientist Barbara Landau. Her work is in the Smithsonian's permanent collection. Johnson lives in Princeton. *Upper image:* "Biography," a print by Lonni Sue Johnson, courtesy of Judith K. Brodsky. *Lower image:* Photograph of Lonni Sue Johnson at work, courtesy of Judith K. Brodsky.

VICTOR L. DAVSON (1948-): Davson received a BFA from Pratt Institute in 1973, and is an artist and the director of Aljira, a Center for Contemporary Art in Newark, NJ. Aljira was designated a Major Art Organization by the New Jersey State Council on the Arts and chosen by the Federal Advisory Committee on International Exhibitions to organize US representation at the IV Bienal Internacional de Pintura in Cuenca, Ecuador. "Aljira Emerge" is an annual program designed to champion both established and under-represented artists, and each spring the center holds an auction of fine art. Davson was born in Georgetown, Guyana. He lives and works in West Orange. "Suns, Coffins, Crosses," lithograph/china colle, by Victor Davson, courtesy of Judith K. Brodsky.

DIANA GONZALEZ GANDOLFI (1951-): Since 1978 Gandolfi has been exhibiting her work in solo and group exhibitions in museum and galleries throughout the US. Her paintings and prints are in numerous private, public, and corporate collections, including the Hunterdon Museum of Art; Noyes Museum; Jersey City Museum; Montclair Art Museum; Johnson & Johnson; Rutgers University; IBM; NJ Department of Treasury; Bank of Boston; and Newark Public Library. *Continues on page 82.*

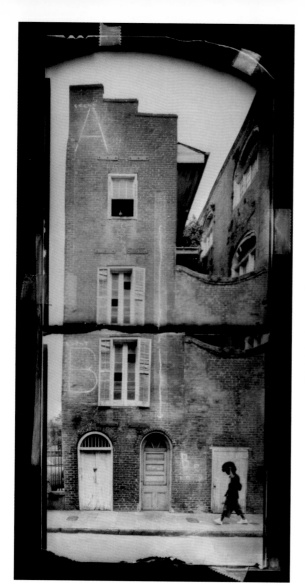

Continued from page 81:
She has received awards, fellowships and residencies from various institutions, including two Boston Museum of Fine Arts Traveling Fellowships; a New Jersey State Council on the Arts Distinguished Artist Award and Fellowship for Printmaking, and two NJSCA Painting Fellowships; a Mid-Atlantic Arts Foundation Painting Fellowship; a Rutgers Center for Innovative Print and Paper Fellowship; and a Geraldine R. Dodge Foundation Residency Grant to attend the Vermont Studio Center. A native of Argentina, she trained as an artist in the US and holds a BFA from Tufts University, a diploma and a Fifth Year Graduate Certificate in Fine Arts from the Boston Museum School, and an MEd in art therapy from the Institute for the Arts and Human Development at Lesley University. "Missing Time," lithograph/china colle/collotraph/monotype, by Diana Gonzalez Gandolfi, courtesy of Judith K. Brodsky.

VINCENT SERBIN (1951-): Serbin was born and raised in South Bound Brook. While attending William Paterson University, Wayne, NJ, he developed an interest in photography and earned a BA in fine arts. In 1978 he moved to the Jersey Shore and opened his own commercial photography studio where he pursued fine art photography. He developed his own style of image-making he calls "the negative collage." During the 1990s, Serbin began to exhibit and sell his work, and in 1994, he received a fellowship grant from the New Jersey State Council on the Arts. In 1996, he moved to Woodstock, NY, where he devoted his time to making photographic artworks, and four years later he was awarded a fellowship grant from the New York Foundation for the Arts. Serbin's work has been featured in many periodicals and books including *Toward Omega*, a book published by the 21st Press. He was also published by George Eastman House in *Picturing Eden*. His work is in museums, institutions, and private collections including the Museum of Photographic Arts; Library of Congress; University of Maine Art Museum; Centre for Photography at Woodstock; and Museet for Fotokunst in Denmark. Over the past decade, he has turned his attention to abstract painting. Serbin lives in Lake Katrina, NY. Photograph "N.O.-ground" by Serbin, courtesy of Vincent Serbin.

JOSEPH AMORINO (1953-): Born in Jersey City, Amorino has worked as a professional artist, educator, researcher, and author for more than thirty years. He earned his doctorate at Columbia University Teachers College, where he subsequently taught for four years before assuming the role of Art Education Program Coordinator at Kean University. His research delves into the psycho-intellectual origins of artistic expressions. Amorino's numerous articles have been featured in leading peer-reviewed journals such as *Studies in Art Education*, *Art Education*, and *Phi Delta Kappan*. His artwork and articles on his teaching methods have also appeared in *The Artist's Magazine*, the *New York Times*, *School Arts Magazine*, and on national educational television's *Channel One News*. *Right:* "The Mind's-eye-Myth" photograph by Serbin, courtesy of Vincent Serbin. *Below:* "The Power of Imagination" photograph by Serbin, courtesy of Vincent Serbin.

His symposiums, presentations, and workshops continue to be well-attended by art educators, therapists, psychologists, artists, and writers. His exhibitions include Gallery Henoch, NYC; National Arts Club, NYC; Rosenberg Gallery of New York University; Macy Gallery at Columbia University Teachers College; and Howe Gallery, Kean University. *Left:* Amorino's painting, oil on formica skin, "Nothing Is Better for Thee Than Me," courtesy of Joseph Amorino. *Below:* Photograph of Joseph Amorino, c. 1981, by Tova Navarra.

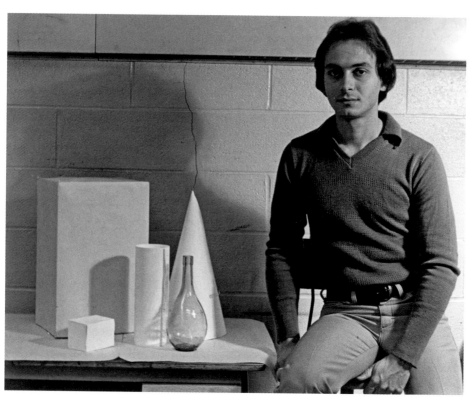

CHAKAIA BOOKER (1953-): Born in Newark, Booker earned a BA in sociology from Rutgers University, 1976, and an MFA from City College of New York (CUNY), 1993. In the early 1990s, she began making art with rubber tires that were transformed into fluid material that represent aesthetic, political, and economic themes, and African-American identity and survival in the modern world. She exhibited work in the 2000 Whitney Biennial, and four of her pieces were on view outside the National Museum of Women in the Arts, Washington, DC. Other exhibitions include Georgia Museum of Art, Athens, GA; New York City's Garment District; Neuberger Museum of Art; Akron Museum of Art; PSI Contemporary Art Center, Queens, NY; the exhibit "Twentieth Century American Sculpture" at the White House, 1996; and "Chakaia Booker: Mass Transit," Indianapolis.

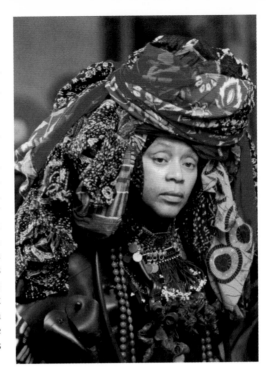

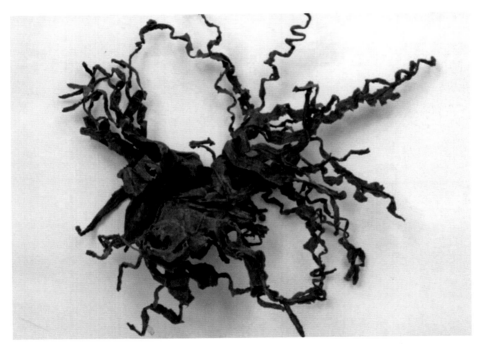

Booker's work is in the permanent collections of the Metropolitan Museum of Art; Akron Museum of Art; Max Protech and June Kelly galleries, NYC;, and other venues. Booker lives and works in New York City. *Upper image:* Photograph of Chakaia Booker, courtesy of Judith K. Brodsky. *Lower image:* Booker's "Impending Encounter," handmade paper with wire and yam armature, courtesy of Judith K. Brodsky.

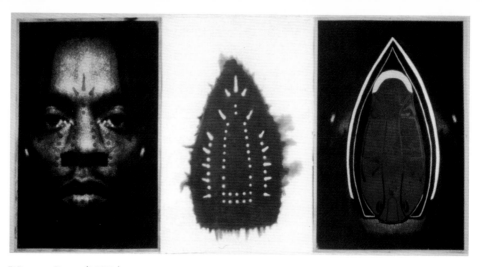

WILLIE COLE (1955-): Cole grew up in Newark, NJ, his birthplace. He attended Boston University School of Fine Arts, earned a BFA from the School of Visual Arts, NYC, 1976, and studied at the Art Students League, 1976-79. For his artworks and installations, Cole assembles items such as irons, ironing boards, bicycle parts, African and Asian masks, high-heeled shoes, discarded appliances, hardware, and lawn jockeys to create critiques of our consumer culture and references to Dada's ready-mades and Surrealism's transformed objects. Cole's work is in more than forty-six museums around the world, including the Metropolitan Museum of Art; MoMA; Whitney Museum of American Art; Philadelphia Museum of Art; Newark Museum; National Gallery of Art, Washington, DC; New Jersey State Museum; Art Gallery of Ontario, Toronto, Canada; FRAC-Lorraine, Metz, France; and Baltimore Museum of Art. Cole lives in Newark. *Above:* Cole's triptych "Man, Spirit, Mask," courtesy of Judith K. Brodsky. *Below:* Photograph of Willie Cole at work, courtesy of Judith K. Brodsky.

LEONID SIVERIVER (1956-): Born in Ukraine, Siveriver was classically trained in Ukraine, Israel, Italy, Austria, and America. As a boy he attended Fine Art School in Frankovsk, Ukraine. He earned a BFA in ceramics from Bezalel Academy in Jerusalem, studied at the Johnson Atelier in Mercerville, NJ, and stone-carving, marble-carving, and bronze-casting in Pietrasanta, Italy. Siveriver has been exhibiting his work for more than thirty-five years; his art is in many collections internationally. A long-time resident of Roosevelt, NJ, he immigrated with his family to Israel. From Italy he came to the US. At the Johnson Atelier he met sculptor Amy Medford, who became his wife and co-founder of Avant-Garde Studios in Roosevelt, which focused on three-dimensional projects. *Continues on page 88.*

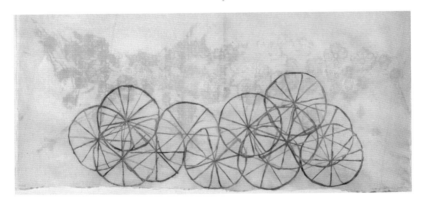

NANCY COHEN (1959-): Cohen studied at the Skowhegan School of Painting and Sculpture, Skowhegan, ME, Columbia University (MFA), and Rochester Institute of Technology, NY, (BFA). She received a number of fellowships, including from Rutgers Center for Innovative Print and Paper, and New Jersey State Council on the Arts for sculpture, and her work is in the collections of Hunterdon Museum of Art; Jersey City Museum; Montclair Art Museum; Noyes Museum; Newark Public Library; Zimmerli Museum; and others. Cohen is an adjunct professor at Queens College, NY, art department, and is former head of the Allen Stevenson School, NYC, art department. She has also completed many commissions and large-scale installations, such as "Perspectives on Salinity 2011" at Richard Stockton College of New Jersey, and a collaborative work, "Sensation: Interior View," at Quark Park Sculpture Garden, Princeton. Cohen lives and works in Jersey City. "Procession" by Nancy Cohen, courtesy of Judith K. Brodsky.

Continued from page 87:

For more than fifteen years Siveriver was an instructor of sculpture at Mercer County College and ceramics instructor at the Lawrenceville School, both in New Jersey. Among his many exhibition venues are New Jersey State Museum; Carnegie Center, Princeton; Ellarslie Museum, Trenton; Trenton State College; Monmouth Museum; Trenton City Museum; and numerous galleries. Siveriver has also exhibited prints, drawings, photographs, glass, metal, stone, and wood pieces. He and Medford own and operate the Artetude Gallery, Asheville, NC. Leonid Siveriver (with Medford) and his sculpture "Spirit #14," and Medford's piece "Conception, terra cotta 35," courtesy of Amy Medford.

AMY MEDFORD (1960-): A Newark, NJ, native, Medford holds an AB in theater history from Cornell University and went on to an apprenticeship at the Johnson Atelier Technical Institute for Sculpture, where she mastered the "lost-wax" method of bronze-casting. At the Atelier, Medford met and married sculptor Leonid Siveriver. She later studied stone-carving at the Studio Palla, in Pietrasanto, Italy, a Tuscan city made famous by Michelangelo's preference for the local stone. Upon her return to the US from Italy, she and Siveriver founded Avant-Garde Studio in Roosevelt, NJ, creating three-dimensional prototype models for clients. Among her numerous exhibitions are the Roosevelt Arts Project; Carnegie Center, Princeton University; Burlington County Sculpture Garden; Gruss Center for Visual Arts, Lawrenceville, NJ; Dorothy Macrae Gallery, Atlanta, GA; Sandarac Gallery, Baltimore, MD; "Ellarslie Open," Trenton City Museum; Monmouth Museum; Wetherholt Gallery, Washington, DC; and Johnson & Johnson, New Brunswick, NJ. From 1990 to 1995, Medford was director of the Quietude Garden Gallery and Sculpture Garden in East Brunswick. For NJN/CTN Channel 8, Medford hosted *State of the Arts* television programs that featured interviews with renowned sculptors and artists, and curated "Roosevelt Artists Past and Present" for Trenton Artworks and Monmouth Museum,1994. Medford has given several lectures on women in the arts and on her sculpture in Princeton; Jupiter, Florida; Levittown, PA, and other areas. She and Siveriver own and operate Artetude Gallery in Asheville, NC. Medford's "We Three Graces, terra cotta 30," courtesy of Amy Medford.

PAUL BENNETT HIRSCH (1960-): Hirsch wrote and illustrated his first book. *Joe and His Alligator*, when he was seven. Born in Providence, RI, he comes from a family of artists: mother a sculptor and painter; father a painter and draftsman, sister Caryn a graphic designer, and sister Michelle, a Chanel representative. Hirsch's family moved to New Jersey in 1973 and while in high school, Hirsch began painting as a photorealist. Thereafter he graduated with a BFA (majors in fine arts and graphic design) in 1983 from the School of Visual Arts, NYC, where he was influenced by lecturers Roy Lichtenstein, Julian Schnabel, Jasper Johns, Robert Rauschenberg, and Don Eddy. *Above:* Hirsch's "#2 Yellow Fatso with Hypo," acrylic on paper, courtesy of Paul Bennett Hirsch. *Below:* Photograph of Hirsch with painting, courtesy of Paul Bennett Hirsch.

Ward Jackson, archivist and director of the Viewing Program at the Guggenheim Museum, NYC, selected Hirsch's work for placement in New Jersey museums and with works by master printers of the Tamarind Lithography Workshop, Zimmerli Art Museum, Rutgers University. Hirsch also exhibited widely and won several awards, and is included in the publications *American Artists: An Illustrated Survey of Leading Contemporaries* and *The New York Art Review*, both published by Les Krantz of American References, Inc., Chicago, IL. Hirsch lives in Washington. *Left:* "Cones" sculpture by Hirsch, courtesy of Paul Bennett Hirsch. *Below:* "Bull," by Paul Bennett Hirsch, courtesy of Paul Bennett Hitsch.

GABRIELA GONZALEZ DELLOSSO (1968-):
Dellosso received a BFA from the School of Visual
Arts, NYC, and continued her studies at the Art
Students League and the National Academy School
of Fine Arts. Her first solo exhibition was at the
Butler Institute of American Art in 2006, fol-
lowed by a solo exhibition at the Eleanor Ettinger
Gallery in 2008. Her work is in the permanent
collections of the Butler Institute of American Art,
Ohio; New Britain Museum of American Art, CT;
Jane Voorhees Zimmerli Art Museum; Salmagundi
Club; and Springfield Art Museum, MO. Her work
has been exhibited in museum invitationals:
"Re-presenting Representation VII" at the Arnot
Art Museum; "Portrait of America: the Nation and
Ohio" at the Butler Institute; "WOMENARTISTS@
NEWBRITAINMUSEUM" at the New Britain Museum;
among others. She has garnered more than twenty-
five awards in the past decade, including gold medals
from the Catharine Lorillard Wolfe Art Club and the
Pastel Society of America. Dellosso is an instructor at
the National Academy School of fine Arts, NYC, and
the JCC of Manhattan. Of Ecuadoran and Cuban her-
itage, Dellosso was born in Queens, NY, and lives
in West New York, NJ. *Right:* Profile photograph of
Gabriela Dellosso, courtesy of Gabriela Dellosso.

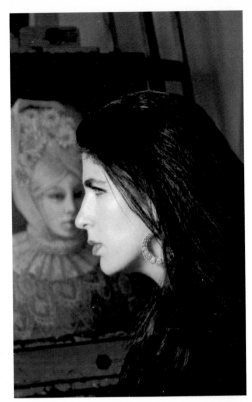

Dellosso's painting "Beatrice Reading – Homage to Dante," courtesy of Gabriela Dellosso.

Dellosso's painting "Garrick (referring to British actor David Garrick), courtesy of Gabriela Dellosso.

STEPHEN R. BREEN (1970-): Born in Los Angeles, Breen started drawing editorial cartoons for the newspaper of the University of California, Riverside, from which he received a degree in political science in 1992. He won the 1991 Scripps Howard Charles M. Schulz Award as top college cartoonist and the John Locher Memorial Award for Outstanding College Editorial Cartoonist. His major influences were Jeff MacNally, Paul Conrad, Pat Oliphant, and Don Wright. In 1994 he was offered a job in the art department of the *Asbury Park Press*, Neptune, NJ, a large daily state newspaper. After becoming the full-time editorial cartoonist at the *Press*, Breen won a Pulitzer Prize, 1998. He continued to work at the *Press* until 2001, when he was hired by *The San Diego Union-Tribune*, CA. He won the Berryman Award, 2007, and in 2009 the Thomas Nast Award. In 2010 came the Fischetti Award, and in 2013 the National Headliner Award and Breen's second Pulitzer. *Right:* Photograph of Steve Breen, courtesy of Steve Breen. *Continues on page 94.*

A Steve Breen cartoon, courtesy of Steve Breen.

Continued from page 93:

His cartoons are nationally syndicated by Creators Syndicate (formerly Copley News Service), and appear regularly in the *New York Times*, *USA Today*, *Newsweek*, and *US News and World Report*. His comic strip "Grand Avenue," syndicated by United Features Syndicate, appears in more than 150 newspapers throughout the nation. Breen has also written and illustrated children's books published by Penguin: *Stick*, *Violet the Pilot*, *The Secret of Santa's Island*, and *Pug and Doug*. Universal recently bought the film rights to Breen's humor book *Unicorn Executions and Other Crazy Things My Kids Ask Me to Draw*, Skyhorse, 2014. Breen lives in San Diego County with his wife and six children.

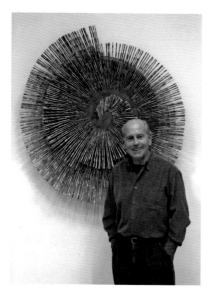 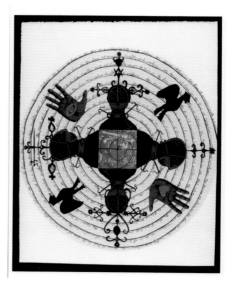

(LEFT) RICCARDO BERLINGERI (1945-): Berlingeri was born in Capri, Italy, and moved to Rome when he was fifteen. In Rome he earned a master's degree in stage and costume design. After many years of work in movies, theater productions, and special events such as the opening of the 1990 World Cup Soccer tournament, Berlingeri moved to the US. In 2010 he started creating sculptures made of discarded materials in response to human-driven deterioration of the natural environment. One of these materials was the *New York Times*, which sculptures were exhibited at the Monmouth Museum and as a solo show at the Middletown Public Library Gallery. He was awarded a New Jersey State Council on the Arts Individual Artist Fellowship. His work is in the collections of the Noyes Museum; Long Beach Island Foundation of Art and Science; Torpedo Factory Art Center; Annemarie Sculpture Garden and Art Center; other museums throughout the US; and many private collections. Photograph of Ricardo Berlingeri in front of his sculpture "Vertigine," courtesy of Riccardo Berlingeri.

(RIGHT) BISA WASHINGTON (1951-): Known for her sculpture emphasizing African heritage and identity, Washington was born in Albany, NY, and is a graduate of Barringer High School and New Jersey City University. She became a Geraldine R. Dodge Artist Resident of the Women's Studio Workshop, where she created handmade paper and mixed-media prints. Among her solo exhibitions are Morris Museum; Garage Gallery, and Arlington Arts, both in Newark; Bethune Museum and National Archives, Washington, DC; and Aljira Gallery, Newark. She has received a number of fellowships, scholarships, and awards, including Mason Gross School of the Arts, Rutgers University; Fellowship Merit Award, Wheeler Foundation, NY; Elena Prentice Rulon-Miller Scholarship; and Haystack Mountain School of Crafts, Deer Isle, ME. A teacher at the Upper School of Visual Arts, Morristown, NJ, Washington's work is in the collections of Newark Museum; Noyes Museum; Morris Museum; New Jersey State Museum; and Rutgers University Dana Library, Newark, as well as in private and corporate collections. Washington lives and works in Newark. "Never Forget," a print by Bisa Washington, courtesy of Judith K. Brodsky.

Tova Navarra is a *magna cum laude* art history graduate of Seton Hall University and former art teacher at Seton Hall Preparatory School, South Orange, NJ. She was the first and only designated art writer/critic in the history of the *Asbury Park Press*, as well as the first writer in the then-111-year history of the *Press* to be internationally syndicated by Copley News Service, San Diego, CA, before the *Press* was purchased by Gannett. Navarra is the author of more than thirty books on diverse topics, including a book of her photographs, *The New Jersey Shore: A Vanishing Splendor* (Philadelphia Art Alliance, 1985). One of her books, *Playing It Smart*, has been translated into six languages. Navarra was born in Newark in 1948 and has been an artist and published writer since age nineteen. Among her many solo exhibitions are O. K. Harris Works of Art, NYC; Gallery Axiom, Philadelphia; a fifteen-year retrospective, 1991 (and a two-person show with Santo Pezzutti, 2007), both at the 800 Gallery, Monmouth University; Atlantic City Art Center; Caldwell College; Millburn Public Library (its first art exhibition). *Right:* "Annunciation," watercolor by Tova Navarra.

Tova Navarra's photograph "Pipe #1, Montreal," of her Pipe Series.

Navarra was also invited to exhibit in Monmouth University's Inaugural Exhibition, November 2012-March 2013, for its new Rechnitz Hall. In addition to numerous group shows including Monmouth Museum's annual juried exhibitions, Navarra exhibited her photographs in a 1992 three-person show with Clarence H. Carter and George Segal at the Payne Gallery of Moravian College, Bethlehem, PA. She served as juror for shows including the 43rd Annual Monmouth Festival of the Arts, 2013. She is a biographical subject in *Who's Who in the East*, *Who's Who of American Women*, *Who's Who in America*, and *Who's Who in the World*, from 1997 to 2015.

CHRONOLOGY: A selection of artists with significant ties to New Jersey, not represented by images:

1755-1828 Gilbert Stuart
1756-1793 Joseph Wright
1766-1839 William Dunlap
1790-1852 John Frazee
1796-1886 Asher B. Durand
1796-1892 George Catlin
1801-1846 Henry Inman
1810-1886 Frederick Ochs
1812-1876 Frances "Fanny" Palmer
1813-1857 William Tyler Ranney
1815-1889 Rembrandt Lockwood
1815-? James Van Dyke
1819-1904 Martin Johnson Heade
1822-1902 Lilly Martin Spencer
1826-1891 Edward Kranich
1836-1910 Winslow Homer
1837-1926 Thomas Moran
1848-1933 Louis Comfort Tiffany
1850-1921 Antonio Jacobsen
1852-1910 Frank Fowler
1861-1912 Charles Schreyvogel
1864-1946 Alfred Stieglitz
1865-1924 Robert Henri
1868-1932 Alfred H. Maurer
1868-1933 George Overbury "Pop" Hart
1869-1944 Ida Wells Stroud
1870-1938 William Glackens
1871-1951 John Sloan
1872-1964 Henry Gulick
1876-1953 Everett Shinn
1879-1972 William Tisch

1880-1964 Gaetano Federici
1887-1949 Walt Kuhn
1887-1968 Marcel Duchamp
1889-1953 Rudolf Bauer
1890-1976 Man Ray
1892-1964 Stuart Davis
1892-1973 Louis Lozowick
1895-1965 Dorothea Lange
1896-1984 Maxwell Stewart Simpson
1898-1954 Reginald Marsh
1898-1992 Elsie Driggs
1898-1976 Alexander Calder
1901-1995 George Price
1902-1968 Lee Gatch
1902-1987 Rex Gorleigh
1903-1984 Benno Prival
1904-1985 Jose Ruiz de Rivera
1904-1999 Loran A. D. Montgomery
1904-1971 Margaret Bourke-White
1904-1980 Roger Duvoisin
1904-1997 Willem de Kooning
1904-1948 Arshile Gorky
1906-1965 Burgoyne Diller
1909-1922 Reginald Neal
1912-1980 Tony Smith
1912-2008 Thomas A. Malloy
1912-2005 James Avati
1913-1995 Leon Bibel
1913-1986 Werner Groshans
1915-1999 Hughie Lee-Smith
1915-? Joseph Wolins

1916-2006 Hella Bailin
1917-2009 Irving Penn
1918-2001 Harry Devlin
1921-1996 Edmond Casarella
1922-2004 Leon Golub
1922-2000 Leonard Baskin
1922-2008 Grace Hartigan
1923-1997 Roy Lichtenstein
1924-2014 Roberta Carter Clark
1925- Robert Mueller
1927- Patricia Vanaman (Pat) Witt
1930- Richard Anuszkiewicz
1931-2004 Leo Dee
1931- Ron Galella
1931- Francis Cunningham
1933- Robert Birmelin
1934- Manuel Ayoso
1936- Frank Stella
1938- Emma Amos
1938- Jonathan Shahn
1938- 1973 Robert Smithson
1939- Peter Barnet
1940- Joan Snyder
1941- Peter Caras
1941- Ben F. Jones
1942- Joyce Kozloff
1945- Barbara Kruger
1946- Alice Aycock
1949-1996 James Colavita
1954- Cindy Sherman
1958- Royce Weatherly

ACKNOWLEDGMENTS

I am profoundly, endlessly grateful to Alan Sutton and Heather Martino, of Fonthill Media, for this book, and to Judith Brodsky, Gary Erbe, and Kenneth Hari for championing my work with their generosity, professionalism, and friendship. Many great thanks as well to all the fantastic artists who contributed images and information that made this book possible, and to Yolanda Navarra Fleming for her unflagging patience and editorial assistance. I also sincerely thank Johnny and Mitzi Navarra, my family, and good neighbors, all who cheered me on. "Self-portrait with Veil" photograph by Tova Navarra.